12 -11

IMAGES
of America

HERMANN

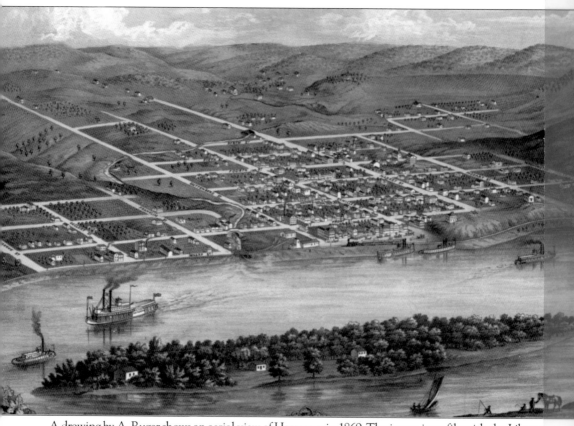

A drawing by A. Ruger shows an aerial view of Hermann in 1869. The image is on file with the Library of Congress, Geography and Maps Division. (Courtesy of Gasconade County Historical Society.)

ON THE COVER: An early Hermann family enjoys a leisurely afternoon. A handwritten inscription on the back of the photograph is partly in German and partly in French. It reads: *"Die guten alten zeiten"* ("The good old times") and *"Dejeuner sur L'herbe, Familie Klinger"* ("Lunch on the grass, Klinger family"). (Courtesy of the Gasconade County Historical Society.)

IMAGES
of America
HERMANN

Dianna Graveman and Don Graveman
with Historic Hermann, Inc. and the
Gasconade County Historical Society

ARCADIA
PUBLISHING

Published by Arcadia Publishing
Charleston SC, Chicago IL, Portsmouth NH, San Francisco CA

Printed in the United States of America

Library of Congress Control Number: 2009943858

For all general information contact Arcadia Publishing at:
Telephone 843-853-2070
Fax 843-853-0044
E-mail sales@arcadiapublishing.com
For customer service and orders:
Toll-Free 1-888-313-2665

Visit us on the Internet at www.arcadiapublishing.com

For Don's siblings: Mary Losapio, Jan Trogdon, Bill Graveman, Martha Young, Kathy Vollmar, and Susan Graveman; and in memory of Dianna's brother, Rick.

CONTENTS

FOREWORD

Hermann, Missouri, has a way of creating strong connections to many folks from many walks of life, across many generations, and for many reasons. The story of the establishment of Hermann in 1836 by the German Settlement Society of Philadelphia to create a colony in the far west to continue and preserve the German language and culture is unique and has created a strong sense of place over time. Our sense of heritage and dedicated efforts to preserve that heritage for six decades are like strong magnets that draw people to Hermann, whether they were born and reared here, have visited Hermann as a tourist, have "married into" Hermann, have found work in Hermann, or have retired in our town.

This book is one more avenue by which individuals may connect to Hermann's heritage, to those who have gone before, and to ways of life that are no more. Whether the reader is a lifelong resident or one who has recently come home, one who has come in search of "Camelot" or a tourist having found a destination, this book illustrates that Hermann is, indeed, a very special place.

The Gasconade County Historical Society through its Archives & Records Center and Historic Hermann, Inc. through its German School Museum, both located at the corner of Fourth and Schiller Streets in downtown Hermann, are partners in fostering connections between individuals and Hermann's heritage. The records center houses the paper history of the Hermann area, and the museum creates tangible connections with that history through tasteful displays of artifacts.

We are proud to be collaborators with the authors in the production of this look into Hermann's story. Through it, may new connections be formed and old connections be reinforced. May we all be dedicated to encouraging those connections for generations to come.

Carol Kallmeyer
German School Museum
Historic Hermann, Inc.

Lois Puchta
Archives & Records Center
Gasconade County Historical Society

ACKNOWLEDGMENTS

For love and support, many thanks to our friends and family, especially the late Doris Musterman, who was always so proud of us. As always, special thanks to Don and Aggie Graveman, Bruce Musterman, and our wonderful children, Stephen, Elizabeth, and Teresa Graveman.

We owe many thanks to Carol Kallmeyer, Donna Layman, Jon Layman, and Phyllis Robinson at Historic Hermann, Inc.'s Museum at the German School; and Betty Held, Jim Held, and Lucinda Huskey at Stone Hill Winery in Hermann. A special thank you and round of applause goes to Horace Hesse and Lois Puchta at Gasconade County Historical Society for the many, many hours they devoted to keeping us on track and telling us tales of Hermann's earlier days.

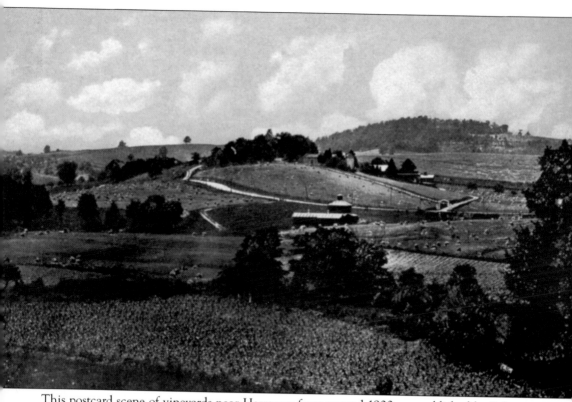

This postcard scene of vineyards near Hermann from around 1900 was published by Schuster Studio. (Courtesy of Historic Hermann, Inc.'s Museum at the German School.)

INTRODUCTION

In 1836, the *Deutsche Ansiedlungs-Gesellschaft zu Pennsylvania* (German Settlement Society of Philadelphia), hoping to establish a colony where German language and customs could be preserved, founded a little town on the Missouri River and named it Hermann. The area was well known to Germans in Philadelphia, partly due to the work of Gottfried Duden, a German researcher and explorer who settled in 1824 near what is now Dutzow. In his book *Bericht über eine Reise nach den westlichen Staaten Nordamerika's* (*Report of a Journey to the Western States of North America*), Duden glowingly described the Missouri River Valley between St. Louis and Hermann and compared the Missouri River to the Rhine in Germany. The book influenced many Germans to settle in Missouri in the 1830s.

Hermann the Cherusker, a German folk hero who defeated the Romans in the Battle of the Teutoburg Forest in 9 AD, became the town's namesake. A statue of the courageous young warrior looms large near the town of Detmold, Germany, and in 2009, the City of Hermann celebrated the 2,000th anniversary of Hermann the Cherusker's historic victory by formally dedicating its own bronze statue of the hero near the north entrance to town.

Hermann grew quickly and in March 1842 became the county seat of Gasconade County, Missouri. The courthouse, built in the years from 1896 to 1898, sits on a high bluff above the Missouri River. The structure was a gift to the county from Charles D. Eitzen, a local merchant, and it may be the only courthouse in the United States to have been a private gift.

By the mid-1840s, Hermann's early residents began growing grapes. The first crop succeeded in 1845, and in 1846, the first wine was made. Michael Poeschel established Stone Hill Winery in Hermann in 1847, and the town celebrated its first *Weinfest* with an elaborate parade in the fall of 1848.

In 1903, local citizens formed a shoe manufacturing company. It was not entirely successful, but in the following year, Peters Shoe Company of St. Louis took over. In 1911, Peters was incorporated into the International Shoe Company, and by 1923, the company employed about 400 workers. International Shoe Company closed its Hermann plant in 1989, but the shoe manufacturing business and the industriousness of Hermann's citizens in the early 1900s may have saved the town during the Prohibition years and the Great Depression that was to follow.

Prohibition threatened to destroy the winemaking industry and the economy of the entire area during the 1920s. Stone Hill Winery's cellars were used for commercial mushroom production for a time, and vineyards were converted to fruit orchards. It was not until the 1960s that Stone Hill was renovated and winemaking again became a profitable business in Hermann.

The first Hermann school was a German school established in 1839 and approved by the Missouri legislature in 1849. In 1842, the public school district was created, and the public and German schools merged in 1871. The old German School building was used as the elementary school until 1955, when classes were moved to a new elementary school building on West Seventh Street. The building was then deeded to Historic Hermann, Inc. for the purposes of establishing a museum.

Maifest is an important part of Hermann tradition and began in the town's earliest years as a May picnic for school children. The children and teachers paraded from the German School to the park carrying American flags, after which they were served pink lemonade (made pink with a touch of red wine) and knackwurst, a type of sausage. In 1952, Maifest was rejuvenated as an event for both residents and tourists and is still celebrated.

Officially designated in 1983, the Hermann American Viticultural Area (AVA) was one of the first recognized by the federal government. Stone Hill Winery, the largest winery in the state, and Hermannhof Winery are within the city's limits. Just south of town is Adam Puchta Winery, the oldest continuously family-owned winery in the United States. It has been under direct family ownership since 1855. Also included in the Hermann AVA are OakGlenn Vineyards and Winery, Bias Vineyards and Winery in Berger, and Bommarito Estate Almond Tree Winery and Röbller Vineyards and Winery, both in New Haven. Early in 2005, these seven local wineries formed the Hermann Vintners' Association, which promotes the Hermann Wine Trail.

Hermann is proud of its history and boasts three organizations devoted to preserving its heritage. More than 110 buildings in the town are listed on the National Register of Historic Places. Historic Hermann, Inc. maintains the museum at the old German School, which was built in 1871. The clock tower, added to the building in 1890, is a popular feature at the museum and a Hermann landmark.

The *Deutschheim* ("German Home") State Historic Site is the German cultural museum of Missouri and is operated by the Missouri Department of Natural Resources. In 1978, the Hermann Brush and Palette Club, a local preservation group, donated several buildings to establish the site. Two main buildings are the Pommer-Genter House, built in 1940, and the Strehly House, built in stages from 1842 to 1869.

The Pommer-Gentner House is an example of German neoclassicism, a style inspired by the classical architecture of ancient Greece and Rome. The house is furnished to reflect life in Hermann during the 1830s and 1840s. It was built in 1840 and is one of the oldest surviving buildings in Hermann.

The Strehly House has a traditional German vernacular front. It once housed a printing company that produced Hermann's first newspaper, *Der Licht Freund* ("Friend of Light"). Around 1857, Carl Strehly built a winery next to the house, which today displays one of the few carved wine casks remaining in the Midwest.

Hermann hosts several annual events, including Maifest and Oktoberfest, which celebrate Hermann's German heritage. Wurstfest, held in early spring each year, is a celebration of the German art of sausage making and promotes Hermann's reputation as the sausage-making capital of Missouri.

"Little Germany," as Hermann has come to be called, draws over a quarter million visitors each year, who spread word of the area's famous wineries, quaint inns, and scenic vistas. Named "Most Beautiful Town in Missouri" by *Rural Missouri* magazine, Hermann truly is a trip to the past—rich in folklore and history—and a lovely place to get away from it all.

One

LITTLE GERMANY

In 1836, the German Settlement Society of Philadelphia formed and began to look for a site where a new German settlement could take root. Three men were chosen to investigate several locations, and they were taken with an area in the new state of Missouri near the confluence of the Missouri and Gasconade Rivers. The society chose board member George F. Bayer to handle the land's purchase and resale to settlers. The first settlers arrived in the newly named town of Hermann in December 1837. However, because of illness, Bayer was forced to remain in Pennsylvania until the following spring. The first few years were very hard, and George Bayer received most of the blame. He died in 1839 and was buried in the local cemetery, still ostracized by the townsfolk of that time. Today Bayer is widely recognized as the founder of Hermann. (Courtesy of Historic Hermann, Inc.'s Museum at the German School.)

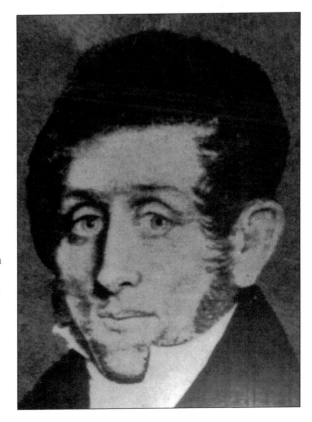

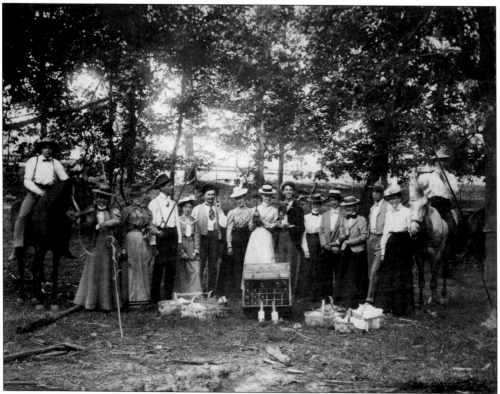

Family and friends gather for an enjoyable Sunday afternoon picnic in this photograph from the late 1800s. Empty wine or other beverage bottles are on display, but it is unclear why an empty bottle hangs from the pole at right. (Courtesy of Gasconade County Historical Society.)

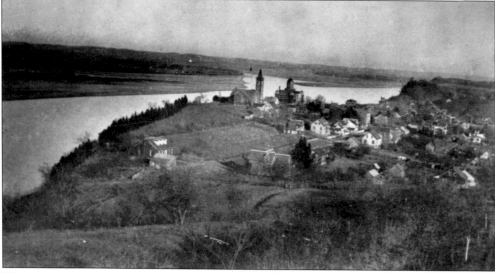

Hermann is pictured as it looked in the early 1900s. The Gasconade County Courthouse is in the center of the photograph, overlooking the Missouri River. A block to the west of the courthouse is St. Paul Evangelical Church, now St. Paul United Church of Christ. (Courtesy of Historic Hermann, Inc.'s Museum at the German School.)

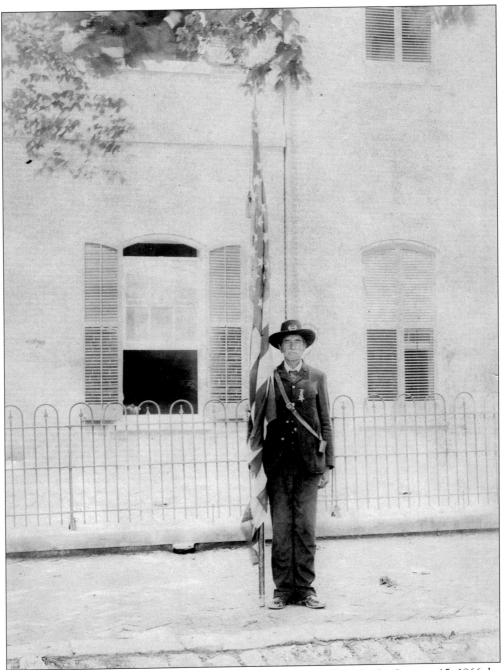

Pvt. Jacob Feil served in the Union infantry under Gen. A. J. Smith. On January 15, 1866, he received an honorable discharge in Memphis, Tennessee, and returned to the family farm on Dry Hill near Hermann. Feil is pictured here beside a large American flag in front of the Hermann elementary school in about 1871. After his return from service, Feil served as a flag bearer for a veteran's organization. (Courtesy of Historic Hermann, Inc.'s Museum at the German School.)

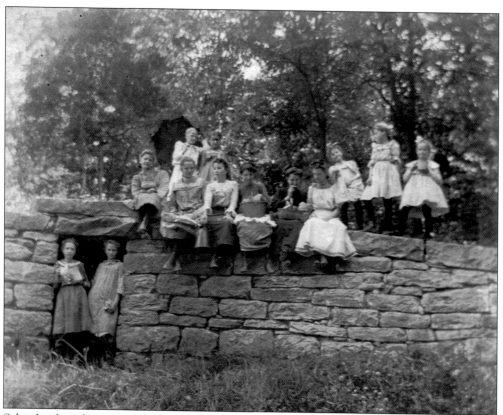

School girls gather on a warm summer day in this photograph from the late 1800s. (Courtesy of Historic Hermann, Inc.'s Museum at the German School.)

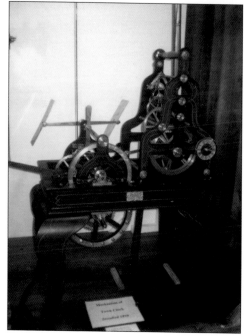

The old clock tower at Historic Hermann's Museum at the German School is a local landmark. The clock tower was not included when the original school was built in 1871. Local citizens took up collections and held drives to raise the needed funds. The clock was installed in 1890 and is still in operation. The clock mechanism, pictured here, is on display inside the museum. (Courtesy of Historic Hermann, Inc.'s Museum at the German School.)

CRAMER. St. Louis, M

Michael Poeschel established his namesake winery in 1847. In 1883, new partners changed the name to Stone Hill Winery. The Stone Hill Winery continued growing until it was the second largest winery in the United States and the third largest in the world. (Courtesy of Historic Hermann, Inc.'s Museum at the German School.)

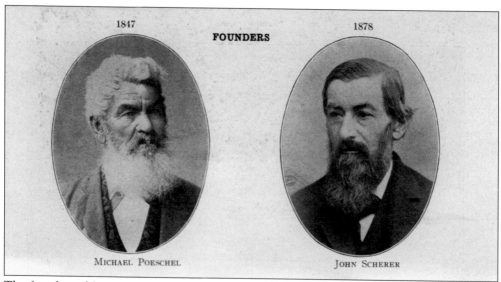

The founders of Stone Hill Winery are seen in this picture from a 65th anniversary brochure. In 1847, Michael Poeschel founded a winery on a hill on the south side of Hermann. In 1861, Poeschel took John Scherer as a partner. (Courtesy of Stone Hill Winery.)

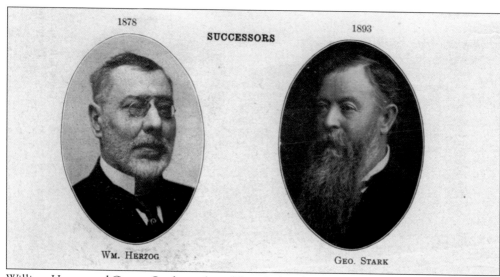

William Herzog and George Stark purchased Poeschel and Scherer's shares of the winery in 1878 and became the sole owners in 1883. Upon Herzog's departure in 1893, Stark became the sole owner. The winery incorporated in 1898 as Stone Hill Winery and grew to be one of the largest in the world. By the turn of the 20th century, Stone Hill shipped over 1 million gallons of wine a year. Stone Hill's operations grew to include a distillery in Kentucky, as well as a bottling plant in St. Louis, Missouri. (Courtesy of Stone Hill Winery.)

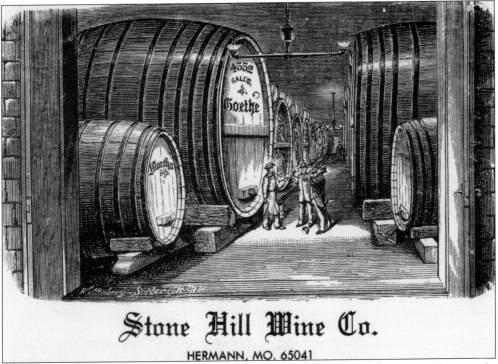

Stone Hill Wine Co.

HERMANN, MO. 65041

During Prohibition, Stone Hill Winery's cellars were used to grow and harvest mushrooms. In 1965, Jim and Betty Held bought the property and began renovation of the winery. (Courtesy of Stone Hill Winery.)

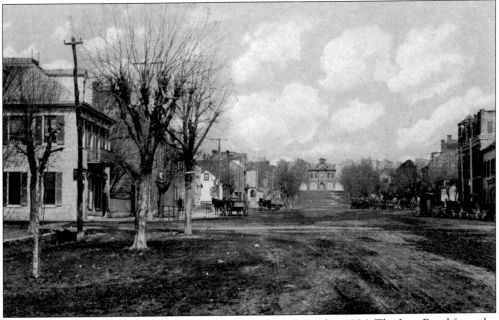

Sharp Corner Tavern is on the left in this photograph taken after 1906. The Iron Road from the Meramec Iron Works made a sharp turn onto Market Street, so the tavern was named Sharp Corner. (Courtesy of Gasconade County Historical Society.)

Hermann Lumberyard is pictured here about 1910. The lumberyard is now at Sixth and Market Streets, and the building that exists today was constructed in 1993. (Courtesy of Historic Hermann, Inc.'s Museum at the German School.)

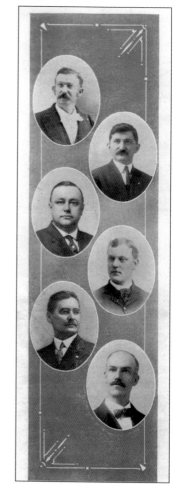

In 1842, a district school was organized in Hermann, and seven years later, Hermann's citizens raised funds to establish the German school of Hermann. They were concerned that if the children were educated entirely in English, they would eventually discontinue use of the mother tongue. The district school appointed six directors in 1867, and in the same year, the German school consolidated with the public school. The board of education of the public school and the board of trustees of the German School were to act together in choosing teachers and other matters. The English Board of Education in 1915, as pictured here, included Theodore Graf, V. A. Silber, J. H. Hasenritter, S. Baumgaertner Jr., A. W. Dietzel, and F. W. Eggers. These photographs were published in the first issue of the senior class yearbook, *Zoe*. The class of 1915 named the book for the Greek word meaning life, and dedicated the first issue to their teacher, Mrs. L. E. Wild. (Courtesy of Historic Hermann, Inc.'s Museum at the German School.)

The German Board of Education in 1915 included George Sohns, R. H. Kasmann, Gus Eberlin, J. M. Schermann, and C. Hansen Jr. The last German school board sat in 1955. (Courtesy of Historic Hermann, Inc.'s Museum at the German School.)

A crest for Hermann, Missouri, and Historic Hermann, Inc. was designed and produced by Mary Streck in 1965. (Courtesy of Historic Hermann, Inc.'s Museum at the German School.)

The Battle At Hermann

OCTOBER, Eighteen-sixty-four,
 The troops of General Price
Were marching on the Capitol,
 And doing things not nice
To natives near Missouri stream;
 Ransacking; scaring all;
And helping selves to what, not yet,
 Was harvested that fall.

In time they neared the German town
 Called Hermann, county seat
Of Gasconade; with hills about,
 And vineyards trim and neat.
Its citizens of Teuton stock,
 Too old to bear a gun,
But still of pep and vigor full,
 Decide to have some fun.

When news arrived the gray-clad boys
 Were marching on their town,
The oldsters chuckled to themselves
 And lost their care-worn frown.
Their plans were quickly made; they then
 With silence met the van
Of Price's army when it hove
 In view at their Hermann.

Officious its leaders were,
 And questions, many, asked
Directly of the citizens
 Who in the sunlight basked.
Then soon the army's men in force
 Were gathered on the way
That led to the State Capitol,
 That fair October day.

Quite suddenly there was a crash—
 A boom—a flash—a noise—
As smoke came down a hillside,
 And a ball, for Rebel boys
Who scurried quick to shelter
 Whence they raked, with rifle fire,
The hillside, and its battery
 That fusilades inspire.

Again the hillsides roar with noise!
 Again the cannon speak,

But from another hill this time—
 More over toward Frane Creek.
Anew, the rounds of shot ring out
 Till smoke soon covers all,
As second hill with ball is combed
 While shrieks the bugle call.

Bewildered now, the boys in gray
 Peer off at both the hills,
Expecting soon a charge in force
 That maims, destroys, or kills.
Now placed in quick formation, they
 Prepared to meet the foe.
A crash—a boom—another hill
 Blazed down on them below!

In haste now, volleys from the squads
 Raked hills with Minie Balls;

Then, ordered forth in grand attack—
 Command the bugle calls.

The hillsides soon were captured:
 Not a shot the chargers faced,

For first and second hills were clear
 When Rebs to summits raced.

PURPOSE

But those who charged so bravely
 To the top of number three
Found, sure enough, a cannon there—
 'Twas spiked—hid by a tree.
In anger now, those boys in gray
 The piece with willing hands
Pushed toward the bluff above the stream
 O'erlooking flooded sands.

With imprecations, rebel yells,
 Sent cannon rolling fast
Down the hillside to the waters;
 In Missouri's flood 'twas cast.
Those gray-clad lads, who sensed the joke
 Marched on with flags held high.
'Twas better so, believed they, too,
 To laugh, instead to die.

Welcome to Hermann and Enjoy The Maifest

"The Battle at Hermann" was printed as a letter to the editor in the *Hermann Advertiser Courier* in May 1952, during Maifest. The contributor is unknown but was from St. Louis. The poem celebrates Hermann's defense of its town when Gen. Sterling Price and his army, in an attempt to secure Missouri for the South during the Civil War, marched on Hermann. (Courtesy of Historic Hermann, Inc.'s Museum at the German School.)

Two

GOVERNMENT AND BUSINESS

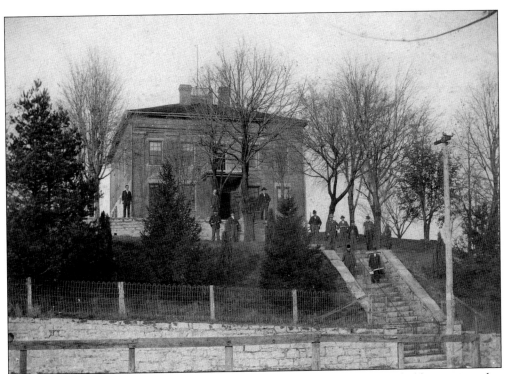

After Gasconade County was organized in 1821, initial court processes were held in a private log cabin near the confluence of the Gasconade and Missouri Rivers. The first courthouse was built about 1842 at a cost of $3,000 to the City of Hermann. It was used until 1896 when a new building was constructed. (Courtesy of Historic Hermann, Inc.'s Museum at the German School.)

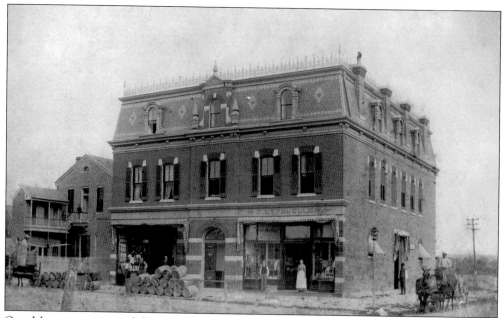

Otto Monnig constructed this building in 1886. In 1889, he moved to Texas and sold the building to Prudot and Scherer. The building faces First Street near the depot in this late 1800s photograph. To the left can be seen a small portion of the White House Hotel. R. C. Mumbrauer was the photographer. (Courtesy of Historic Hermann, Inc.'s Museum at the German School.)

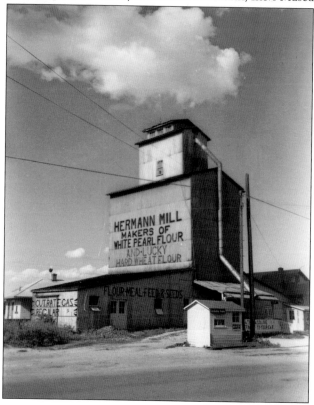

Hermann Mill, pictured here in earlier times, is undergoing restoration in 2010. Across the street from the Hermann Mill is Hermann Star Mills, built in 1867. (Courtesy of Gasconade County Historical Society.)

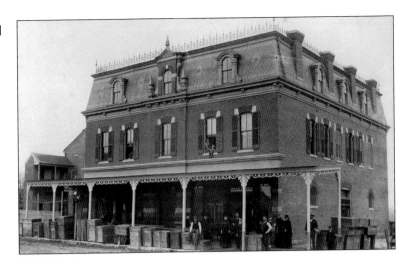

The old Prudot and Scherer building on First Street backed to Wharf Street and the river. (Courtesy of Historic Hermann, Inc.'s Museum at the German School.)

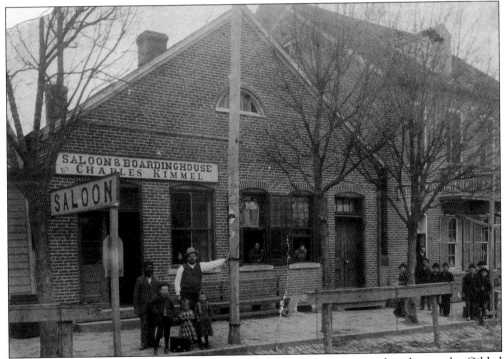

Market Street is pictured here in 1890, during what was sometimes referred to as the Gilded Age. The building on the left was owned by Charles Kimmel, who operated the Charles Kimmel Saloon and Boarding House. This building was later enlarged, and a story and a half was added. A candle-powered lamp is attached to the pole to light the front of the boardinghouse. Pictured from left to right are John Deflorin, Hans Kimmel, Herman Kimmel, Annetta (Augustine) Kimmel, and Charles Kimmel. The two women in the windows, from left to right, are Annetta Kimmel and Hannah Ochsner Niehoff. At right is the Farmer's Home Hotel, which was owned by Bernhard Niehoff. Individuals on the far right are unidentified. (Courtesy of Historic Hermann, Inc.'s Museum at the German School.)

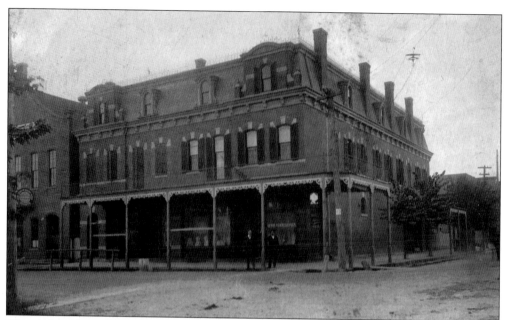

"Gent's furnishings" are advertised in the window of Bocklage Men's Wear at Front and Schiller Streets in this photograph donated to Historic Hermann, Inc. by George Bocklage, son of Ted Bocklage. The store was in business for over 50 years. August Begemann built the structure for his son Armin, who opened a grocery and dry goods firm there with John Helmer in 1893. Armin Begemann purchased the interest of Helmer and later sold in 1930 to John Trippe. (Courtesy of Historic Hermann, Inc.'s Museum at the German School.)

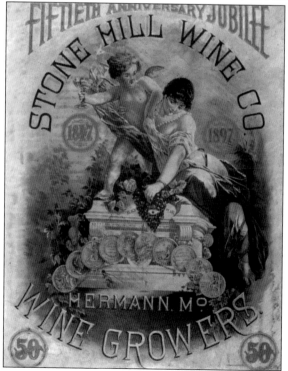

Stone Hill Wine Company announced its 50th anniversary with this poster in 1897. George Stark had become sole owner in 1893. In 1898, the Stone Hill Wine Company was incorporated under Missouri law. (Courtesy of Stone Hill Winery.)

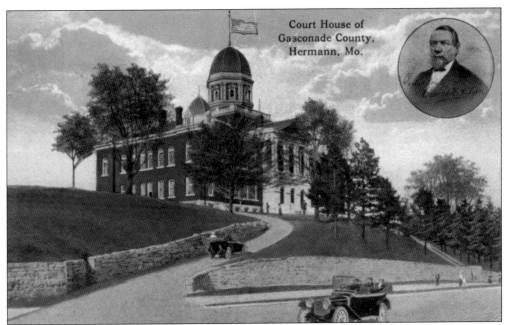

A view of the courthouse is depicted in this early 1900s postcard. The courthouse was built with private funds, and it is believed to be the only one in the country that was not financed by taxpayers. Charles D. Eitzen, who was born in Bremen, Germany, in 1819 and immigrated to Hermann in 1839, bequeathed $50,000 upon his death to build the new courthouse. (Courtesy of Stone Hill Winery.)

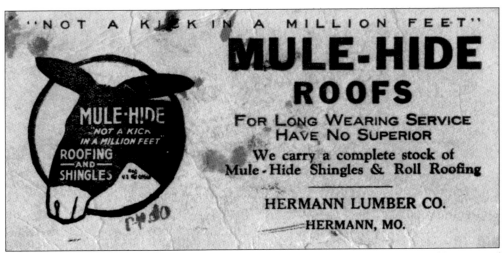

Mule-hide roofs were advertised by Hermann Lumber Company in the early 1900s. (Courtesy of Gasconade County Historical Society.)

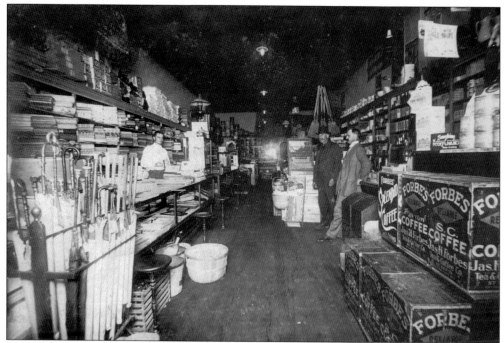

John Helmer's store was on Fourth Street in the early 1900s. George M. Mueller stands behind the counter. The man wearing a hat is unidentified. John Helmer is on the right. (Courtesy of Gasconade County Historical Society.)

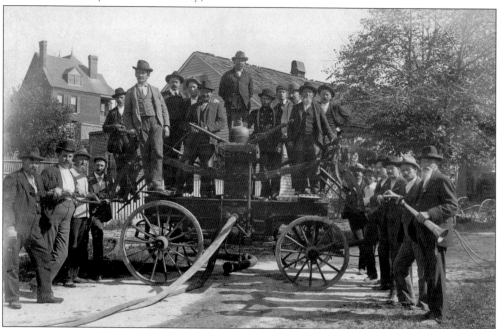

Hermann's fire department is pictured in the early 1900s with a Washington hand pumper that was sold to Hermann Fire Company in 1861. It is believed the hand pumper had been built in Pawtucket, Rhode Island. It was often used in parades. (Courtesy of Historic Hermann, Inc.'s Museum at the German School.)

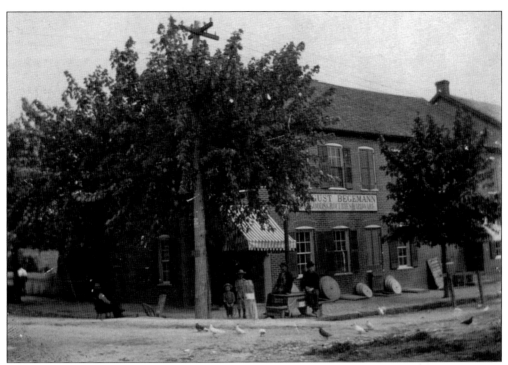

August Begemann Dry Goods, Groceries, and Hardware store is pictured here about 1900. (Courtesy of Historic Hermann, Inc.'s Museum at the German School.)

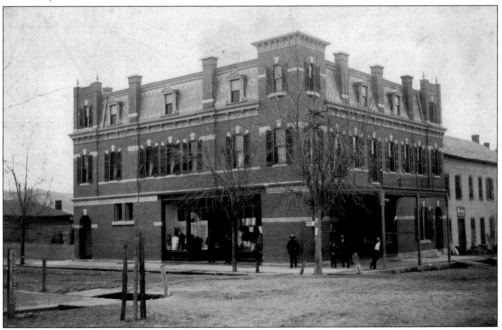

Another Begemann building, located on the southeast corner of Fourth and Market Streets, was built around the turn of the 19th century by August Begemann as a mercantile business for his son Louis. Today it is a bed and breakfast. (Courtesy of Historic Hermann, Inc.'s Museum at the German School.)

The walls of Stone Hill Winery's 60-foot-by-60-foot main building are 12 inches thick. The building is featured on this postcard from about 1900. (Courtesy of Historic Hermann, Inc.'s Museum at the German School.)

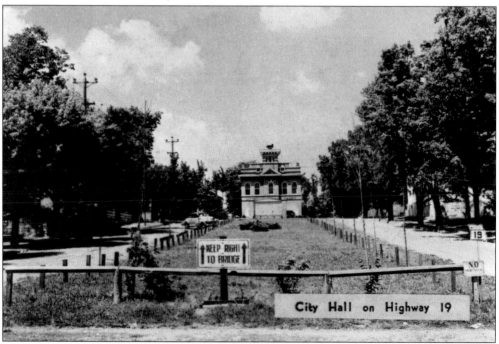

City Hall, pictured here, was built in 1906 and still stands on U.S. Highway 19. The lower level originally served as a firehouse but is currently not used for that purpose. Plans are in place for the building to eventually become a visitor center and tourism office. (Courtesy of Historic Hermann, Inc.'s Museum at the German School.)

Hermann Savings Bank, shown here on East First Street in the early 1900s, is now First Bank. (Courtesy of Historic Hermann, Inc.'s Museum at the German School.)

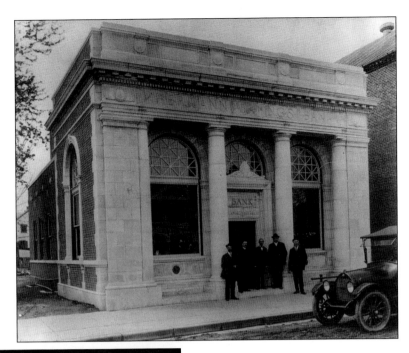

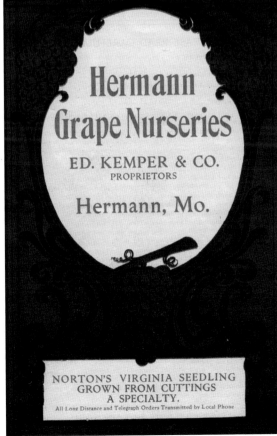

In 1897, Edward Kemper took over his father's grape-growing business, renaming it the Hermann Grape Nurseries. In 1900, at the urging of George Husmann, he went to the University of Missouri in Columbia to learn more about propagating and developing new varieties of grape plants that would be disease resistant. There a professor advised the students that Norton's Virginia Seedling could not be grown from cuttings. Edward protested that he had been growing Virginia Seedlings from cuttings for over five years. When he later had catalogs printed for his nurseries, he advertised "Norton's Virginia Seedlings Grown From Cuttings, a Specialty" on the cover. (Courtesy of Gasconade County Historical Society.)

29

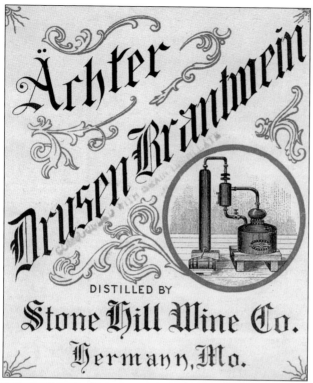

In addition to its prize-winning wines, Stone Hill Winery—under the direction of George Stark—operated a distillery in Kentucky and a large bottling plant with offices in St. Louis. A label for *Ärhter Drusen Brantwein* is pictured here. (Courtesy of Historic Hermann, Inc.'s Museum at the German School.)

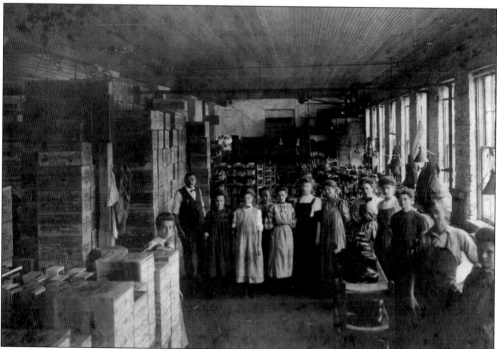

In 1903, a few citizens banded together to form a shoe manufacturing company, which was not very successful. However, the following year, Peters Shoe Company of St. Louis took over the operation. (Courtesy of Gasconade County Historical Society.)

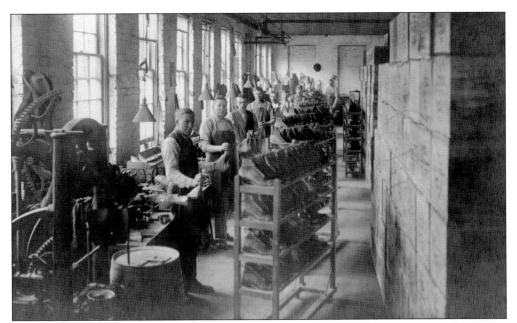

Peters Shoe Company boxes are seen in the factory in this picture from about 1905. The factory was located at Fourth and Gutenberg Streets. Leather for the shoes was delivered in barrels on horse-drawn wagons. The area in front of the shoe factory was paved with bricks before other parts of town because of heavy traffic to the factory. (Courtesy of Gasconade County Historical Society.)

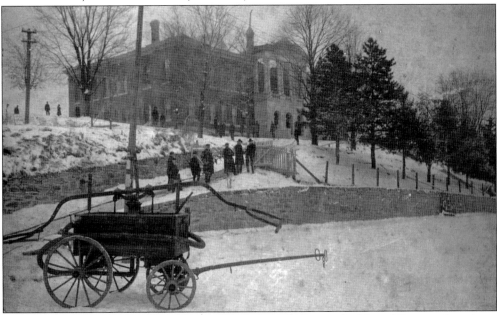

The Gasconade County Courthouse is probably the only one in the United States to have been built with private funds. Charles D. Eitzen willed approximately $50,000 to the government to build the courthouse, which was erected in the years from 1896 to 1898. Eitzen also donated land for a city park. In 1905, the courthouse was damaged by fire. The entire dome, the roof, and a portion of the second floor were destroyed, as can be seen in this photograph. A fire pumper sits in the foreground. (Courtesy of Gasconade County Historical Society.)

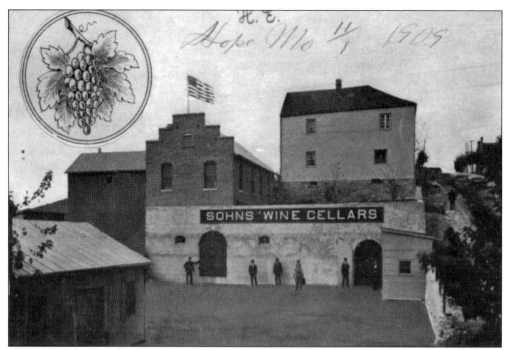

Sohns Wine Cellars is featured in this postcard published by Selige Publishers in 1909. Sohns drew business from out-of-town visitors as well as the Hermann community. (Courtesy of Historic Hermann, Inc's Museum at the German School.)

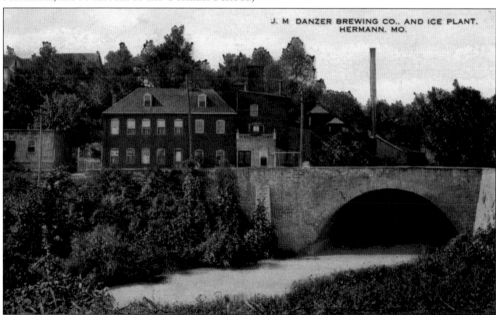

Kropp Brewery, today the home of Hermannhof Winery, was at East First Street. The brewery made ice year round, using a sulphur system, instead of getting it from the river. Employees had to wear masks, because it was dangerous to manufacture ice this way. The building was constructed by Jacob Strobel in 1855 or 1856. J. M. Danzer was operating this brewery at the time of the photograph in 1910. (Courtesy of Historic Hermann, Inc.'s Museum at the German School.)

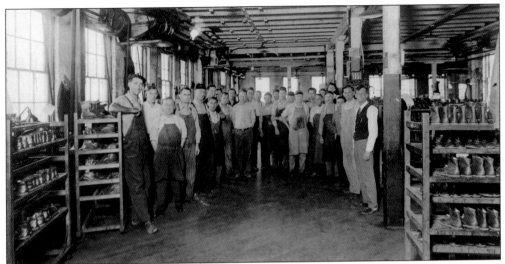

In 1911, International Shoe Company was formed with the merger of Peters Shoe Company and Roberts, Johnson, and Rand Shoe Company. A three-story addition was built in 1923, and the company then employed about 400 workers. (Courtesy of Historic Hermann, Inc.'s Museum at the German School.)

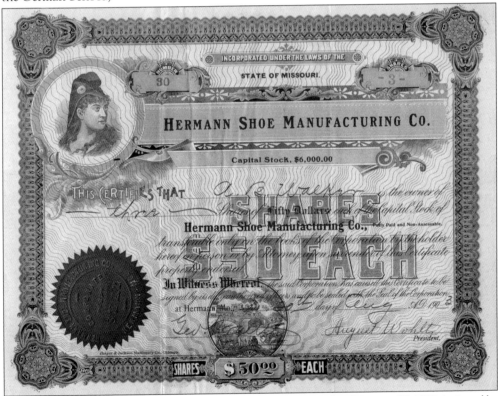

This Hermann Shoe Manufacturing Company stock certificate, dated August 20, 1903, is signed by company president August Wohlt. The company was formed by local citizens but was purchased by Peters Shoe Company in 1904, which later merged with Roberts, Johnson, and Rand Shoe Company to become International Shoe Company. (Courtesy of Gasconade County Historical Society)

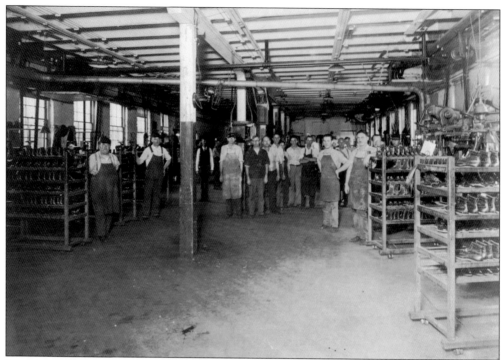

International Shoe Company employees are pictured during the early years. (Courtesy of Gasconade County Historical Society.)

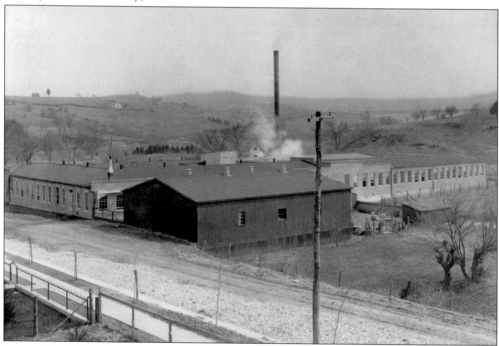

International Shoe Company is pictured here in the early 1900s. By the 1960s, the company had dedicated a $360,000 modern plant in the southern part of town. (Courtesy of Historic Hermann, Inc.'s Museum at the German School.)

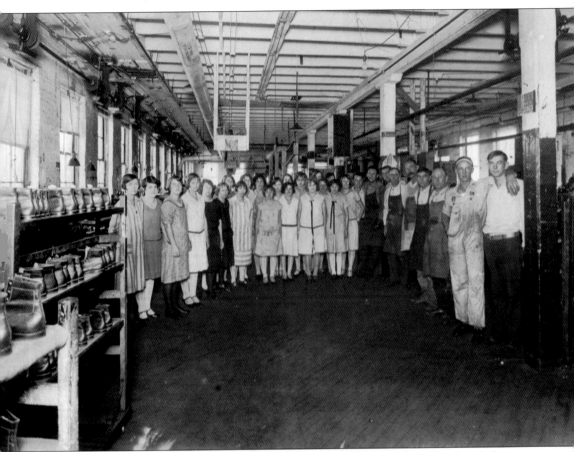

International Shoe Company employees take a break from work to pose for a photograph during the 1920s. The shoe company was the first to put toe reinforcements on open shoes to hold the shape. (Courtesy of Gasconade County Historical Society.)

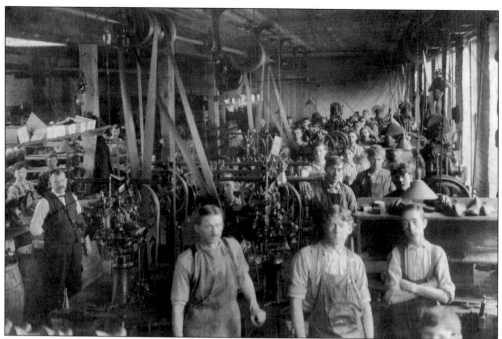

The International Shoe Company plant is crowded with workers and machinery in this early 1900s photograph. By 1955, most of the national company's 36,000 employees and 60 plants were located in Missouri. Their factories produced 52,313,612 pairs of shoes that year. (Courtesy of Historic Hermann, Inc.'s Museum at the German School.)

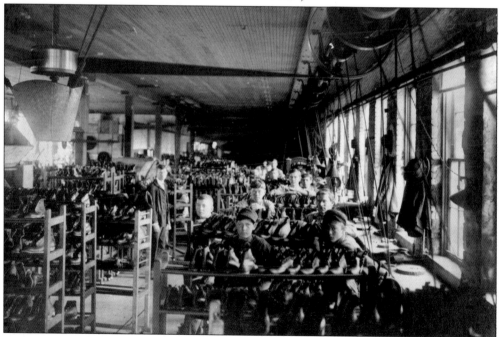

International Shoe Company closed its plants in Hermann, Missouri, and Paducah, Kentucky, in 1989. Young workers posed for this photograph in Hermann during the company's early days. (Courtesy of Historic Hermann, Inc.'s Museum at the German School.)

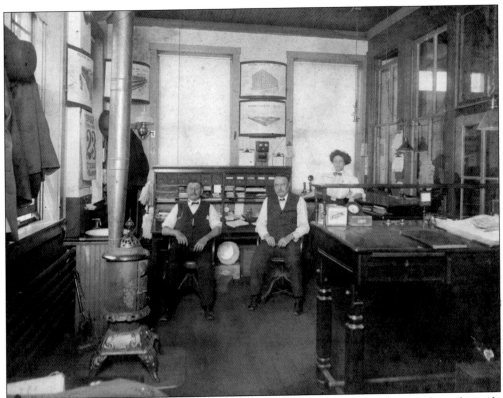

Peters Shoe Company photographs hang on the office walls in this photograph from the early 1900s. The calendar on the far left indicates it is Tuesday, March 23. The year is not visible, but March 23 fell on a Tuesday in 1909, suggesting the date for this picture. (Courtesy of Historic Hermann, Inc.'s Museum at the German School.)

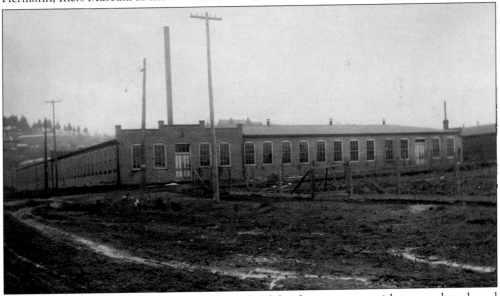

Edward Zoff snapped this very early photograph of the shoe company with unpaved roads and chickens in the yard. (Courtesy of Historic Hermann, Inc.'s Museum at the German School.)

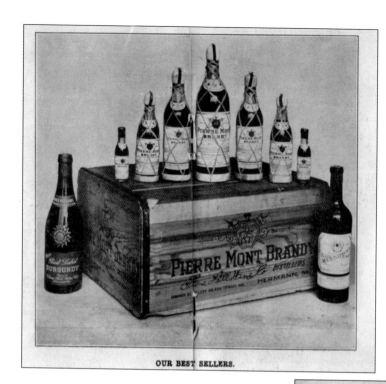

OUR BEST SELLERS.

Stone Hill Winery's 65th anniversary brochure from 1912 advertises its best sellers of the time. The fine wines at Stone Hill won gold medals in at least eight world exhibitions, including those at Vienna, Austria, in 1873; Paris, France, in 1878 and 1889; and St. Louis, Missouri, in 1904. (Courtesy of Historic Hermann, Inc.'s Museum at the German School.)

1847 1912

65th Anniversary

Stone Hill
Wine Co.

Wine Growers
. . . . and
Brandy Distillers

HERMANN, MISSOURI

Stone Hill Wine Company distributed this brochure to celebrate its 65th anniversary in 1912. The brochure includes company history, photographs, and a list of gold medals won at world's fairs up to that time. (Courtesy of Historic Hermann's Museum at the German School.)

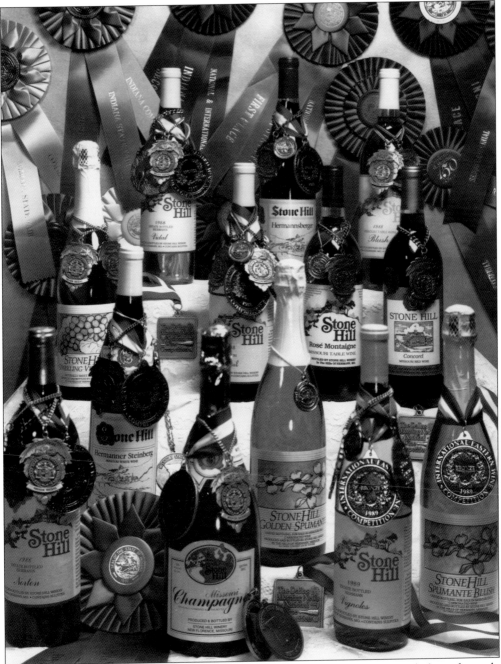

Award-winning wines from Stone Hill Winery are featured in this photograph from the early 1900s. The wine company's products had won eight gold medals at world exhibitions by 1904. (Courtesy of Stone Hill Winery.)

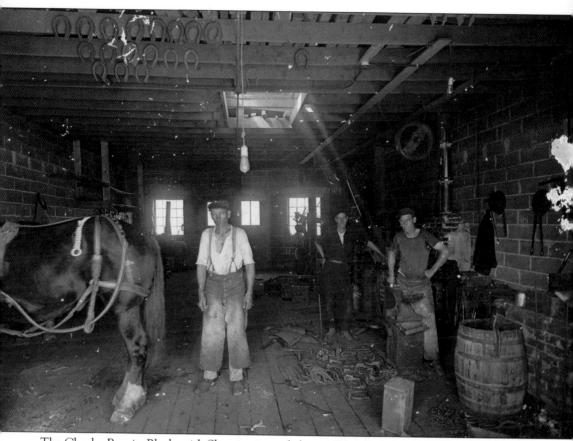

The Charles Paneitz Blacksmith Shop is pictured about 1930. The building, located on the south side of West Fifth Street, was constructed in 1887 by Charles Rieger to be used as a blacksmithy and wagon-maker's shop. The building later became a cleaners but is no longer standing. Charles Paneitz rang the bell at St. Paul Evangelical Church, today St. Paul United Church of Christ, for many years. He and his wife later became custodians. Charles was born in 1881 and died in 1968. (Courtesy of Gasconade County Historical Society.)

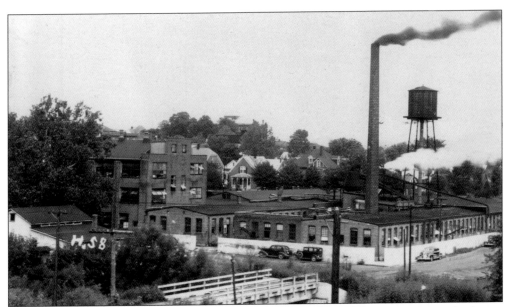

This postcard from the 1930s shows International Shoe Company. The company was the first to change insole and outsole patterns on open heels during that decade. (Courtesy of Gasconade County Historical Society.)

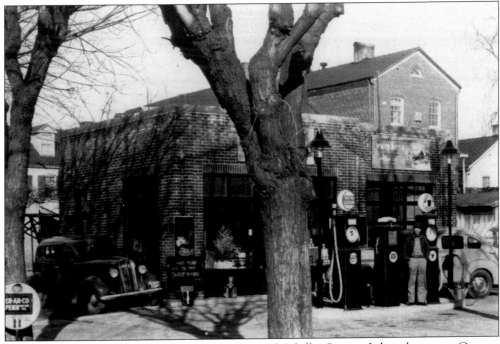

The White Rose gas station was located at First and Schiller Streets. It later became a Conoco Station. This photograph from the 1930s was taken around Christmas time, as evidenced by the decorated tree in the window. (Courtesy of Gasconade County Historical Society.)

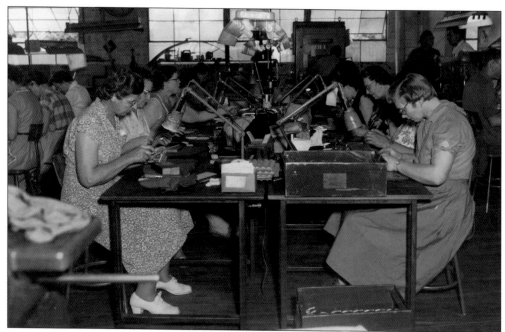

Bernice Naegelin, pictured on the right, works alongside other Ritepoint Company workers in the late 1940s or early 1950s. Ritepoint manufactured pens, but during the Korean War it also made heads for big munitions shells. The Hermann plant only operated from about 1948 through 1954. It was located on Jefferson Street on the west side of Hermann; the building still stands. The company employed 225 to 425 people. Parts of the plant operated three daily shifts throughout the year. (Courtesy of Gasconade County Historical Society.)

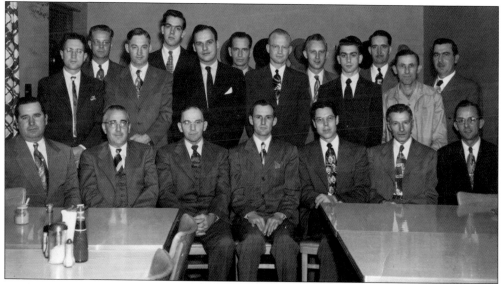

Employees at the Ritepoint Company posed for this photograph. Pictured from left to right are (first row) Charlie Temple, Farnhorn Boyle, Clint Potter, Harold Hillebrand, Deo Blott, Hugo Schultz, and Ed Kruse; (second row) Ed Schoenhoff, Ed Rathsom, Ed Wright, Howard Messer, Burnell Horstmann, and Dave Eggenberg; (third row) Roy Uthe, Neal Schwartz, Willard McMillan, Maurice Strunk, Jim Snead, and Walter Schulte. (Courtesy of Gasconade County Historical Society.)

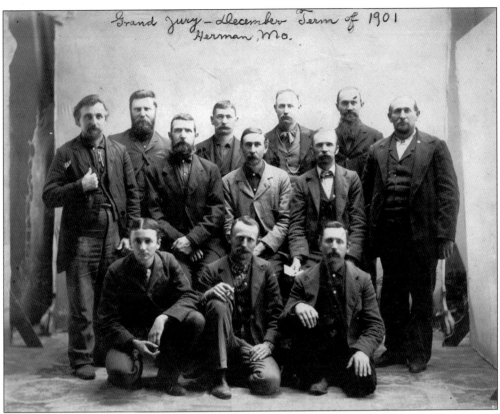

Grand Jury – December Term of 1901 Herman, Mo.

A grand jury assembled in 1901, as it did every year, to inspect county property and to be prepared in case they were needed to settle other matters. (Courtesy of Historic Herman, Inc.'s Museum at the German School.)

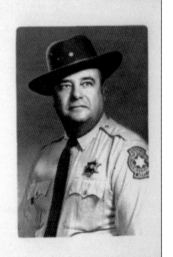

RE-NOMINATE

HARRY J. HEBERLE

For
SHERIFF OF GASCONADE COUNTY

**At The Republican
Primary Election Aug. 8**

EXPERIENCED PROFESSIONAL – WW II VETERAN

Hermann resident Harry J. Heberle served as sheriff of Gasconade County from 1957 through 1974. Pictured is one of the business cards his campaign distributed during an election year. (Courtesy of Gasconade County Historical Society.)

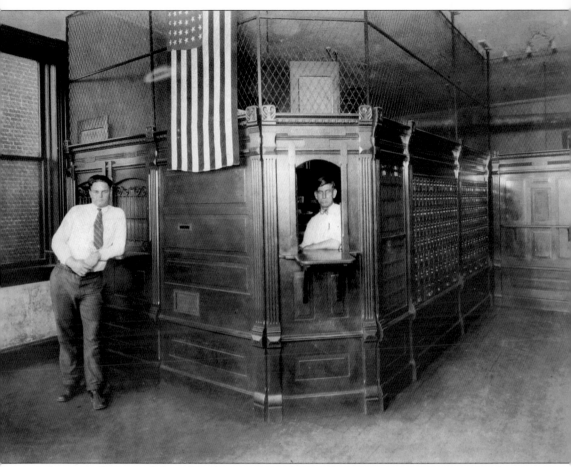

This post office served the public for many years from its location on East First Street until it was replaced in 1972. Shown in this interior view of the building are Waldo Sherman on the left and, it is believed, Roy Patton on the right. This building was replaced in 1972 by a new facility on East Fourth Street constructed by Historic Hermann, Inc. It has since been replaced by a building on West 16th Street. (Courtesy of Gasconade County Historical Society.)

Three

CHURCHES AND SCHOOLS

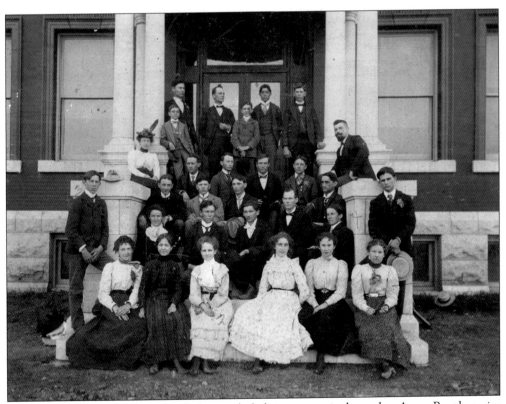

The 1902 Hermann High School class included, in no particular order, Anna Roethemeier (Wessel), Margaret Klinger (Blosser), August Graf, J. Graf, and Leander Graf. (Courtesy of Historic Hermann, Inc.'s Museum at the German School.)

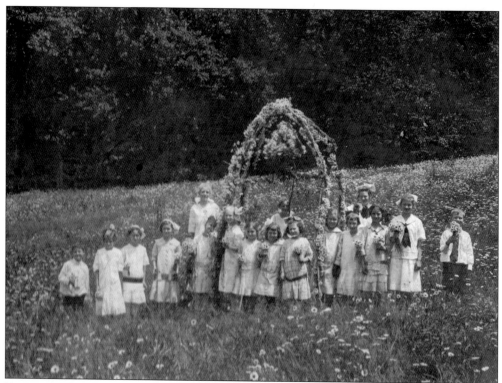

Young school children pose under a trellis in a field of flowers in this photograph from the early 1900s. (Courtesy of Historic Hermann, Inc.'s Museum at the German School.)

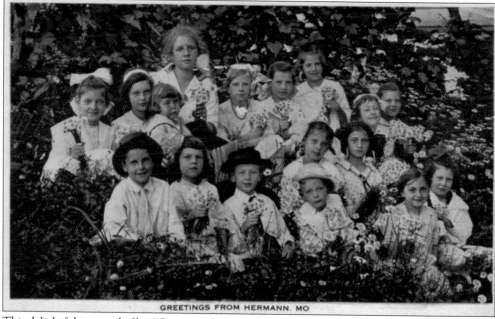

GREETINGS FROM HERMANN, MO

This delightful postcard offers "Greetings from Hermann, MO," and likely went home as a souvenir with many of the town's visitors at that time. The postcard required just 1¢ to mail. (Courtesy of Historic Hermann, Inc.'s Museum at the German School.)

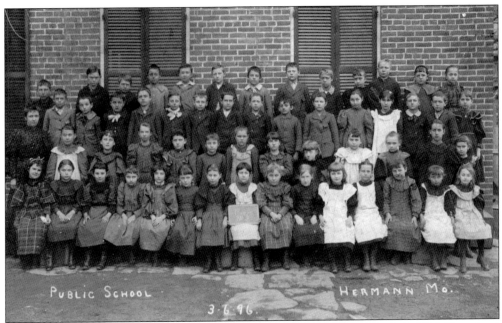

Hermann Public School children are pictured in this photograph dated March 6, 1896. The school was also called the German school, since it operated under both English and German school boards. The German language was taught at the school to all grades for many years. (Courtesy of Gasconade County Historical Society.)

The St. Paul Evangelical Church women's group, *Frauenverein*, celebrated its 50th anniversary in 1905. The congregation formed in 1844. As the result of a vote in 1854, women who were married to church members and became widows were allowed to become members of the congregation if they met qualifications for donating and attendance. The *Frauenverein* later became Ladies Aid and today is Women's Fellowship. From left to right are (front row) Dora Ruediger, Julia Klenk, Ida Hoersch, and Katie Wensel; (second row) Mrs. ? Schneider and Rev. Henry Bender. (Courtesy of Gasconade County Historical Society.)

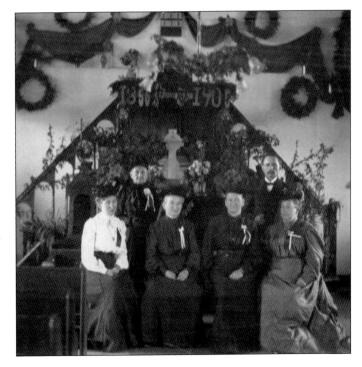

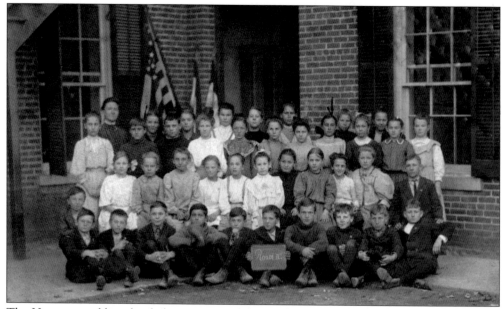

The Hermann public school class is pictured during the 1904–1905 school year. The students' teacher was Mrs. L. E. Wild. (Courtesy of Gasconade County Historical Society.)

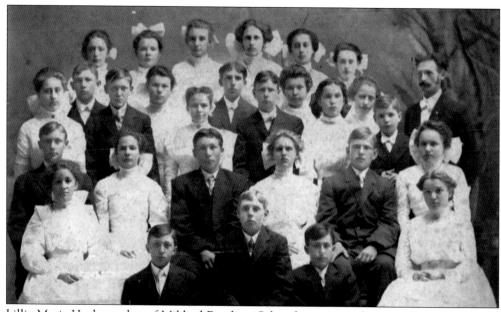

Lillie Marie Huck, mother of Mildred Ruediger Schmidt, is pictured second from right in the fifth row in this eighth grade graduation photograph from about 1910. (Courtesy of Gasconade County Historical Society.)

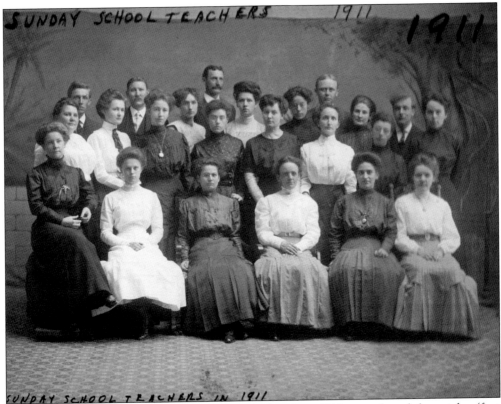

Sunday school teachers at St. Paul Evangelical Church in 1911 were, from left to right, (first row) unidentified, Alma Fleeman, Mrs. Paul Streck, unidentified, Mrs. Velada Habsieger, and unidentified; (second row) all unidentified except ? Sohns at far right; (third row) August Baumstark, two unidentified, Pastor Suedmeyer, three unidentified, Mrs. August Baumstark, and unidentified. (Courtesy of Gasconade County Historical Society.)

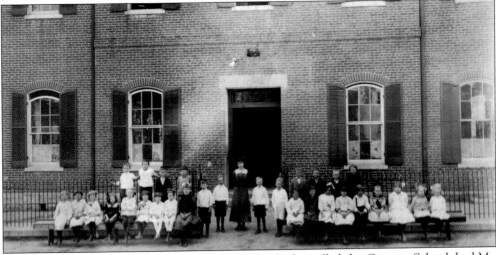

The 1914 first grade class at Hermann Public School, also called the German School, had Ms. Alma Poeschel for their teacher. The students are unidentified. (Courtesy of Historic Hermann, Inc.'s Museum at the German School.)

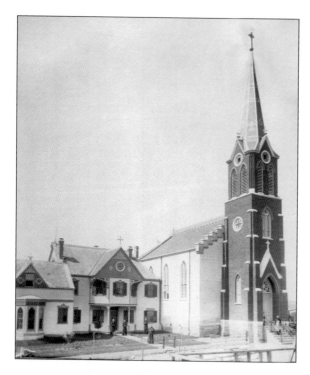

St. George Catholic Church kept the steeple from the old church building when it was rebuilt. This photograph was taken before 1914, because the entrance faces north. When the church was rebuilt, the entrance was located on the west. (Courtesy of Historic Hermann, Inc.'s Museum at the German School.)

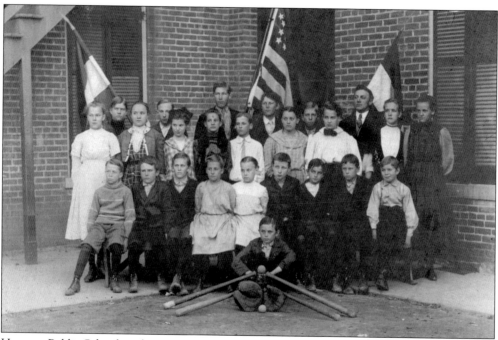

Herman Public School students are pictured here in 1915. The class included, in no particular order, Bernice Dirkson, Louis Brunner, Lucille Fischer Drusch, Ruth Slocumb, Hulda Wohlt, Caroline Kolb, Oliver Ochsner, Lorene Begemann, Leander Graf, Wilma Ruediger, Hugo Fricke, and Erwin Haid. Some of the students are not identified. (Courtesy of Historic Hermann, Inc.'s Museum at the German School.)

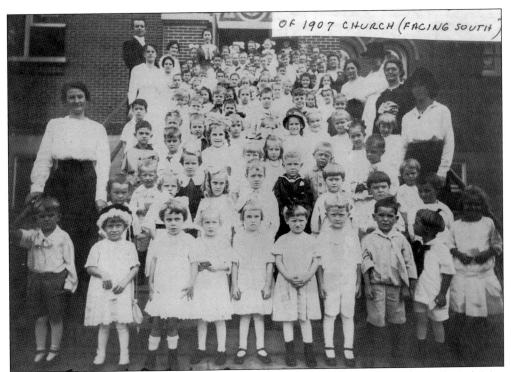

St. Paul Sunday School teachers in 1920 included (from bottom left and moving clockwise), Mrs. August Baumstark, Mrs. Otto Fleeman, pastor R. H. Kasmann, Mrs. Frieda Kasmann, Frau Streck, next three unidentified, and Mrs. Otto Lettmann. Some of the students, in no particular order, are Rudolph Fischer, Martin Habsieger, Virgil Sohns, George Van Horn, Elfrieda Salzmann, Vera Kasmann, Evelyn Kasmann, Herman Fischer, Burnett Buttermann, and Dorothy Heckmann. (Courtesy of Gasconade County Historical Society.)

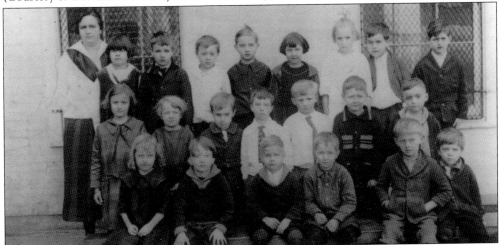

Mrs. Humphries taught the first grade class at Hermann's public school in 1924. Some of the students, in no particular order, are Elton Moore, Raymond Kramme, Julius Schaeffer, Emily Ruediger, Elmer Tekotte, Henry Heckmann, Waldo Paneitz, Kenneth Masse, Harvey Bretthorst, Paul Evan, Elmer Zimmerman, Fred Beckman, Marie Eberlin, and Lucas Kramer. (Courtesy of Historic Hermann, Inc.'s Museum at the German School.)

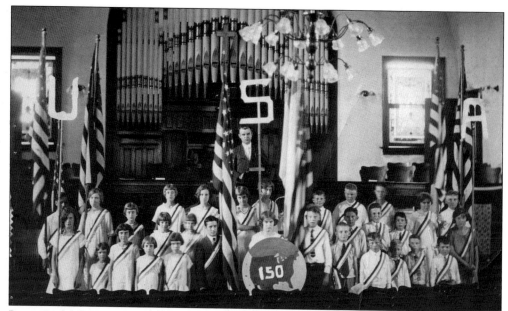

Pastor Rudolph Kasmann and some members of the St. Paul Evangelical Church Sunday School class in 1926 celebrate the 150th anniversary of the signing of the Declaration of Independence. Class members hold large cutouts of letters spelling "USA." Some of the students, in no particular order, are Alda Lensing, Norma Fricke, Emily Sohns, Florence Rulle, Selma Haeffner, Aduna Sell, Evelyn Kasmann, Leonard Doll, Burnett Buttermann, Vera Kasmann, Dalton Scheidegger, and Virgil Paneitz. The pastor is in the pulpit, and the choir loft and organ are behind him. (Courtesy of Gasconade County Historical Society.)

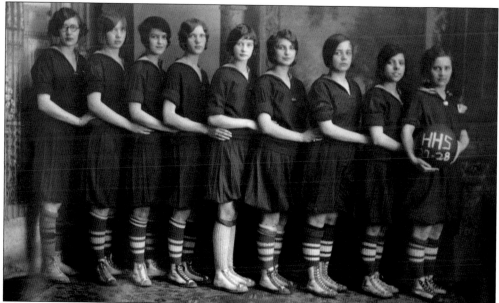

The Herman High School freshman girls basketball team in 1927 and 1928 included, from left to right, Lenora Scharnhorst, Eleanora Bundrick, Marie Tekotte, Myrtle Scharnhorst, Esther Shermann, Bernice Redeker, Imogene Story, Gladys Hilt, and Louise Kuhn. (Courtesy of Gasconade County Historical Society.)

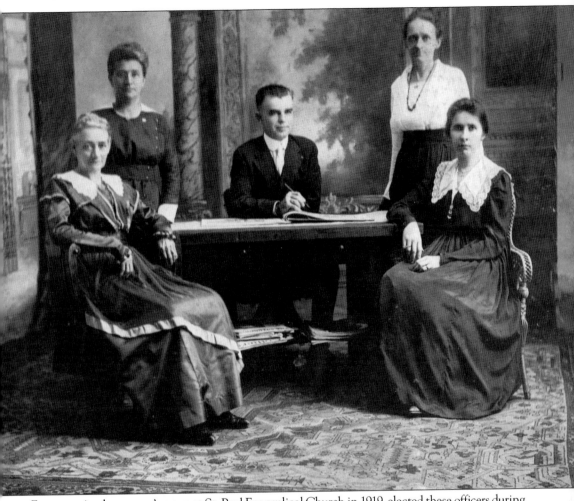

Frauenverein, the women's group at St. Paul Evangelical Church in 1919, elected these officers during its 75th anniversary year as a congregation. From left to right are (first row) Frau Fritz Heinke, *Schatzmeisterin* ("Mistress of the Treasury"); and Frau R. H. Kasmann, *Sekretarin*; (second row) Frau Paul Streck, *Präsident*; Pastor R. H. Kasmann; and Frau William Heckmann, *Vizepräsident*. (Courtesy of Gasconade County Historical Society.)

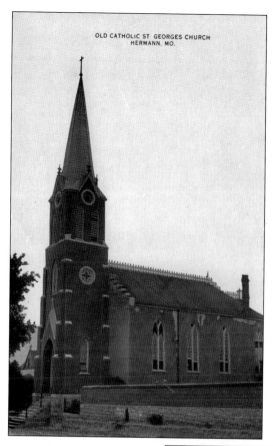

St. George Catholic Church was organized in Hermann in 1840, but no priest was assigned to the parish until 1849. A parochial school was founded in 1868, and the church was rebuilt and enlarged in the early 1900s after this photograph was taken. (Courtesy of Gasconade County Historical Society.)

The old clock tower was not a part of the original German School structure when it was built in 1871. Legend has it that early Hermann residents, many of whom did not carry watches, often gathered for a bit of conversation on the bench at the German School. It is said someone crossed the street almost daily to ask, "*Was ist die Uhr?*" ("What time is it?"). Christina Graf was instrumental in getting the town fathers to erect the clock tower, which today has become a Hermann landmark. (Courtesy of Historic Hermann, Inc.'s Museum at the German School.)

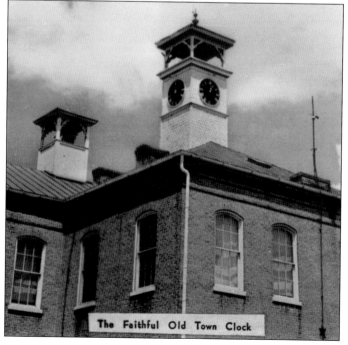

The Faithful Old Town Clock

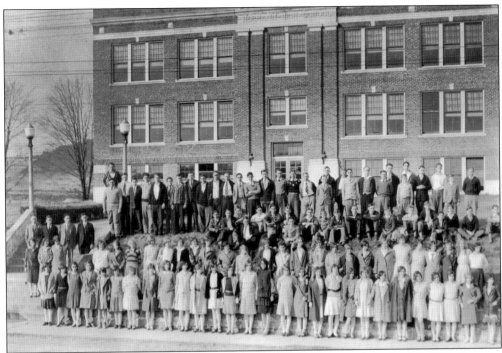

Students and teachers of Hermann High School pose for a photograph in the fall 1929, about six years after the building opened. (Courtesy of Gasconade County Historical Society.)

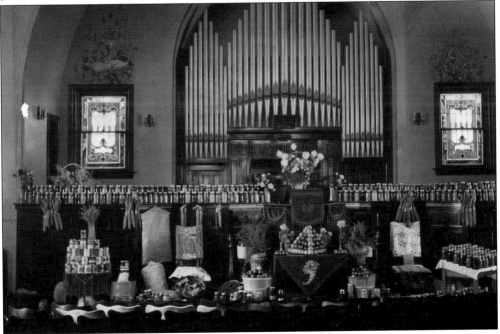

St. Paul Evangelical Church's women's group, *Frauenverein*, organized an annual harvest collection of food for the Emmaus Home in Marthasville. This particular "Fall Ingathering," as it was called, took place in the 1940s. The tradition continued into the 1950s. (Courtesy of Gasconade County Historical Society.)

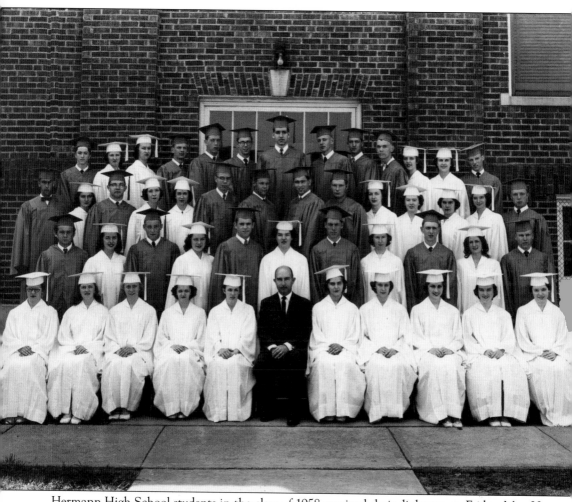

Hermann High School students in the class of 1958 received their diplomas on Friday, May 23, 1958. From left to right are (first row) Diann Schneider, Marilyn Pohlmann, Darlene Zastrow, Marjorie White, Clydine Kuhn, Ralph Sellenschutter (class sponsor), Rose Marie Brautigam, Barbara Muskopf, Phyllis Coulter, Kathryn Slover, and Donna Howard; (second row) Calvin Lionberger, Marilyn Uher, Gary Beul, Alice Eikel, Charles Baur, Lois Aubuchon, Rudolph Theissen, Lena Mae Landwehr, Daniel Bohl, Pat Kraus, and Larry Hauser; (third row) Gerald Riley, Rochelle Hoffmann, Kenneth Lerbs, Joyce Willimann, Lenora Fredrick, Carl Marsch, Tommy Boehm, Ray Montgomery, Harlan Drury, Carol Jo Morrow, Mary Ann Steinbeck, Carol Egley, Melva Benz, and Robert Bethel; (fourth row) George Reisbig, Georgia Ann Schulte, Janet Kropp, Gene Kotthoff, Richard Schooley, Don Lerbs, James Kallmeyer, David Ruck, Drew Pehle, Earl Fleer, Arline Brinkmann, Lois Gumper, and Dennis Hord. Orlando Mundwiller was not present when the picture was taken. (Courtesy of Gasconade County Historical Society.)

Four

Parades and Celebrations

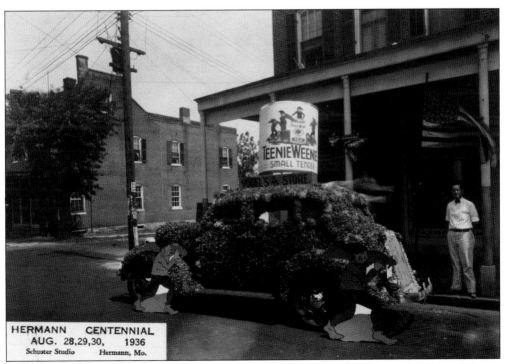

HERMANN CENTENNIAL
AUG. 28,29,30, 1936
Schuster Studio Hermann, Mo.

Vogel's Store entered a float in the 1936 centennial parade that displayed a "can" of Teenie Weenie small, tender peas on top of the car and elves "running" alongside it. The photograph was taken in front of Vogel's store and was featured on a postcard by Schuster Studio. (Courtesy of Historic Hermann, Inc.'s Museum at the German School.)

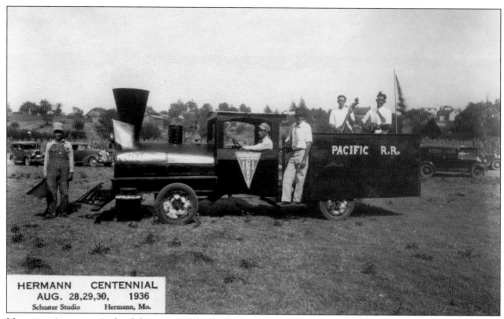

HERMANN CENTENNIAL
AUG. 28,29,30, 1936
Schuster Studio Hermann, Mo.

Hermann's centennial celebration took place on August 28, 29, and 30, 1936. Although Hermann's earliest residents did not begin arriving until 1837, the German Settlement Society of Philadelphia formed in 1836 and began selling shares of stock to raise funds for the undertaking of finding and establishing a German colony. A Pacific Railroad car was part of the centennial parade, as shown on this Schuster Studio postcard. The Pacific Railroad completed its tracks west through Hermann in 1854. (Courtesy of Historic Hermann, Inc.'s Museum at the German School.)

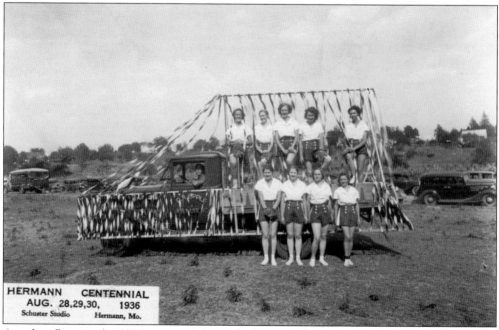

HERMANN CENTENNIAL
AUG. 28,29,30, 1936
Schuster Studio Hermann, Mo.

Another float in the 1936 centennial parade featured the C. R. Epple Softball Team. The photograph was taken by Schuster Studio. (Courtesy of Historic Hermann, Inc.'s Museum at the German School.)

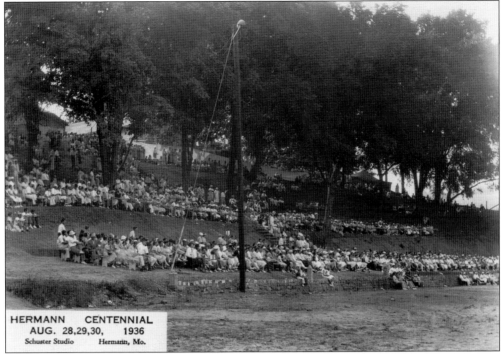

A crowd gathers at the Hermann City Park to watch the 1936 centennial parade. The celebration took place August 28, 29, and 30, 1936. The postcard was produced by Schuster Studio. (Courtesy of Historic Hermann, Inc.'s Museum at the German School.)

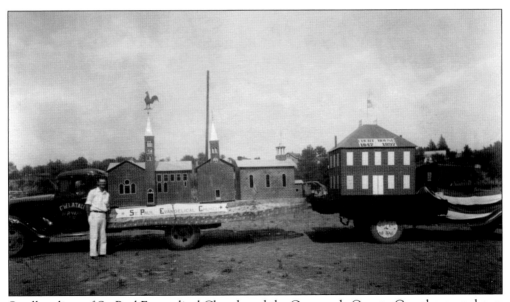

Small replicas of St. Paul Evangelical Church and the Gasconade County Courthouse make up a 1936 centennial parade float being pulled by F. W. Latall in this Schuster Studio photograph. (Courtesy of Historic Hermann, Inc.'s Museum at the German School.)

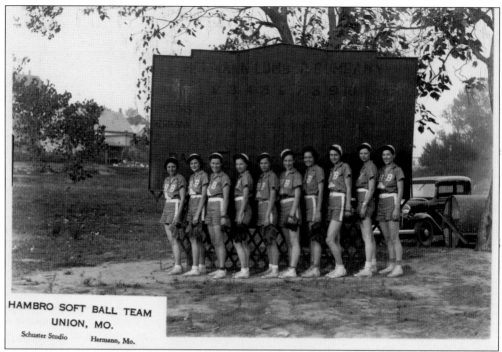

This photograph of the women's Hambro Softball Team from Union, Missouri, was taken in Hermann between 1936 and 1939 in front of the Hermann Lumber Company scoreboard. (Courtesy of Historic Hermann, Inc.'s Museum at the German School.)

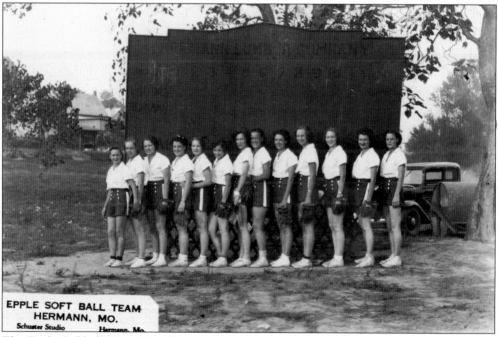

The Epple Softball Team from Hermann poses in front of the Hermann Lumber Company scoreboard in a photograph taken between 1936 and 1939. (Courtesy of Historic Hermann, Inc.'s Museum at the German School.)

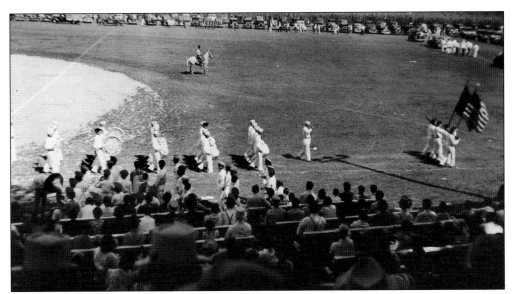

This view of the Hermann homecoming in 1939 was featured on a Schuster Studio postcard. The back of the postcard reads: "You are cordially invited to attend the annual Hermann Homecoming, August 31 and September 1, 1940. Bring your friends to 'The City Beautiful on the Banks of the Missouri.' A good time awaits you at the Hermann Homecoming." Homecoming continued to be held annually into the 1960s. (Courtesy of Historic Hermann, Inc.'s Museum at the German School.)

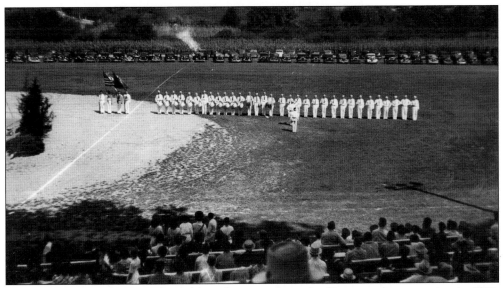

A drum corps performs on the field in this view from the Hermann homecoming in 1939. The postcard is from Schuster Studio. (Courtesy of Historic Hermann, Inc.'s Museum at the German School.)

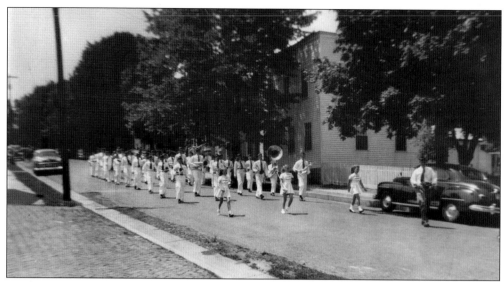

A school band marches in the 1953 Maifest parade on East Second Street. Three young majorettes are out in front. LaNette (Wagner) Kotthoff is the majorette on the far right. Maifest is an important part of Hermann tradition and began in the town's earliest years as a May picnic for school children. In 1952, Maifest was rejuvenated as an event for both residents and tourists and is still celebrated. (Courtesy of Gasconade County Historical Society.)

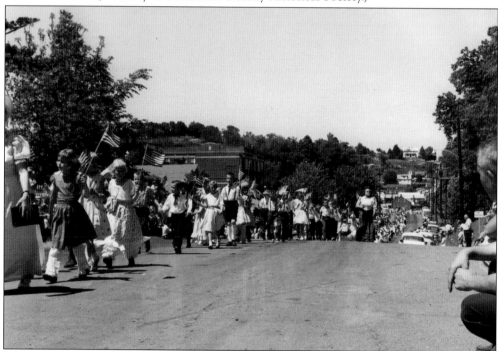

During Maifest in the 1950s, it was traditional for children and their teachers to parade from the German School to the park carrying American flags, after which they were served pink lemonade and knackwurst. In this photograph, the children are parading up Washington Street. The entrance to the park is on the right; the high school is in the background on the left. The teacher is Bernice Spurgeon, who taught second grade. (Courtesy of Gasconade County Historical Society.)

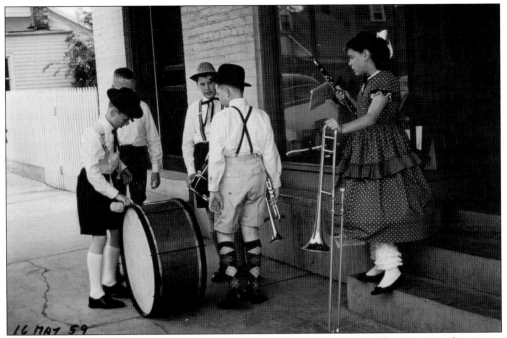

Young musicians dressed for the occasion gather in front of Schlender's Shoe Store at the corner of First and Schiller for the 1959 Maifest. (Courtesy of Gasconade County Historical Society.)

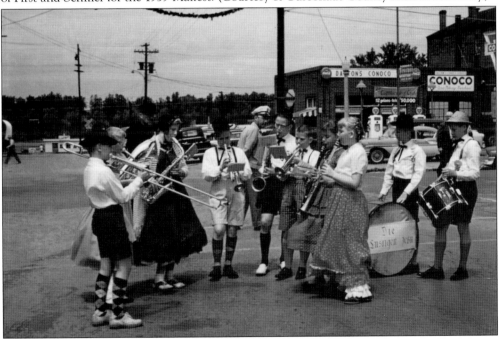

An elementary school band, dressed for Maifest, plays their musical instruments on the street on May 16, 1959. The German words on the drum translate as "The Merry Ten." Pictured from left to right are Billy Wessel, Jane Paneitz, Bonnie Paneitz, Steve Huff, Wayne Grannemann, Terry Fischer, LaDonna Brown, Charlotte Helmich, Roy Schroff, and Gregory Allemann. (Courtesy of Gasconade County Historical Society.)

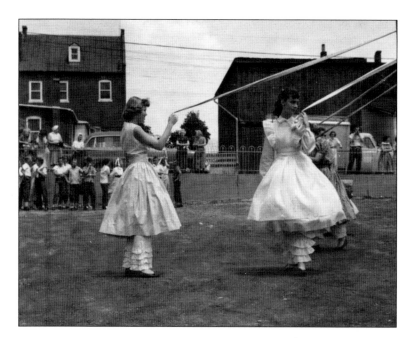

Janet Lenger (left) and Sandra Fleisch dance around the maypole during Maifest in the 1950s. The maypole dance took place on the German School playground. (Courtesy of Gasconade County Historical Society.)

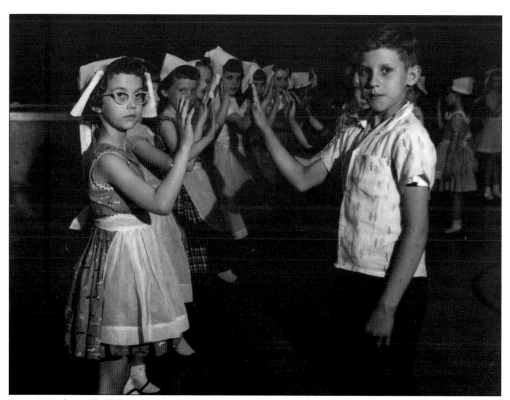

Patsy Humburg (left) lines up with her classmates to perform a traditional dance during Maifest. The boy on the right is unidentified. (Courtesy of Gasconade County Historical Society.)

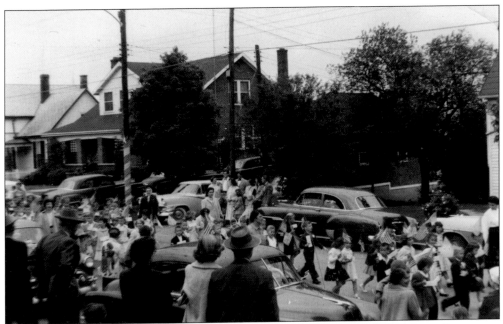

Children parade down the street at Maifest in the 1950s, carrying small American flags as was tradition. School children would be issued flags on the school grounds, and the flags were collected at the end of the parade route by a teacher for use the next year. (Courtesy of Gasconade County Historical Society.)

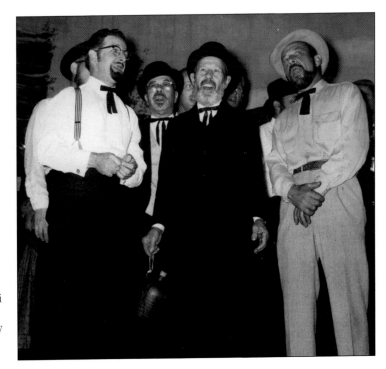

Maifest pageants were held each year from 1952 through 1964. The pageants were written by Anna Hesse. Shown performing in a 1950s pageant are, from left to right, unidentified, Clarence Hesse, Dr. W. A. Jeter, Kenneth Schneider, Walter Schuetz (wearing hat), Belt Kendrick, unidentified man in back, Leander Roetheli (wearing hat), and unidentified. (Courtesy of Gasconade County Historical Society.)

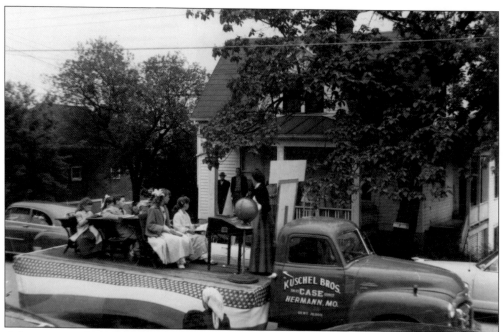

A farm tractor dealership, Kuschel Brothers, pulls a float with school children and their teacher in a Maifest parade during the 1950s. (Courtesy of Gasconade County Historical Society.)

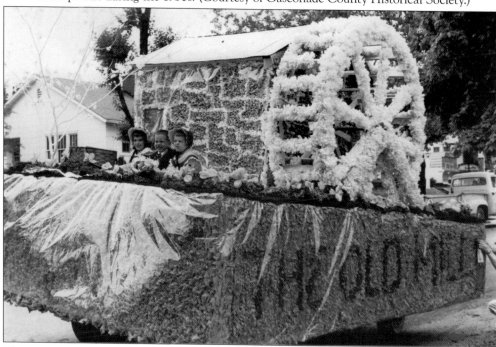

Three small children nestle down in the the Old Mill float during a 1950s Maifest. Although the historical pageants ended in 1964, Maifest has continued and is still celebrated. However, there is less focus on the history of the town, and the celebration has more of a festival atmosphere. Visitors from far and near come to celebrate Maifest with Hermann's townsfolk. (Courtesy of Gasconade County Historical Society.)

Historic Hermann's float in this 1950s Maifest parade featured a replica of the German School building. The children on the float are Diane Wagner and Richard Greene. (Courtesy of Gasconade County Historical Society.)

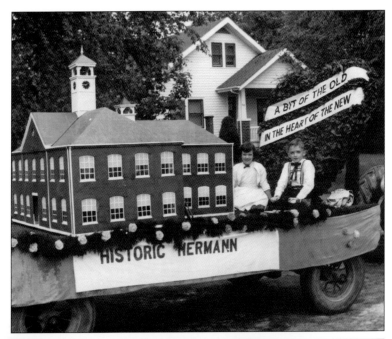

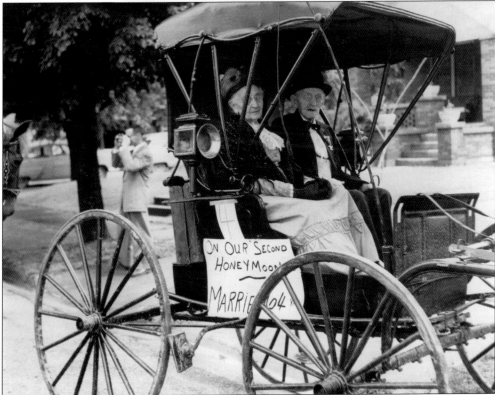

Fred "Fritz" and Louisa Tinnemeyer Koeller and their horse-drawn carriage were a delightful addition to the 1959 Maifest parade. The sign on their carriage says: "Second honeymoon. Married 64 years." (Courtesy of Gasconade County Historical Society.)

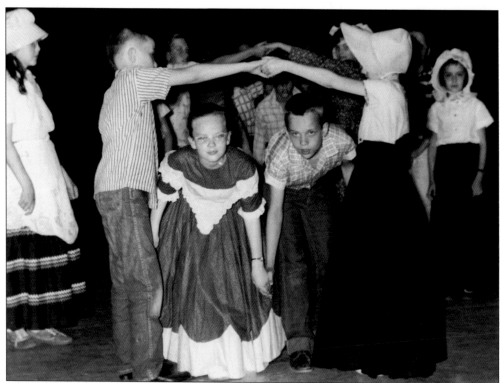

Linda Shaw and Kenneth Beckmann duck beneath the clasped hands of other school children during a traditional Maifest dance in the 1950s. (Courtesy of Gasconade County Historical Society.)

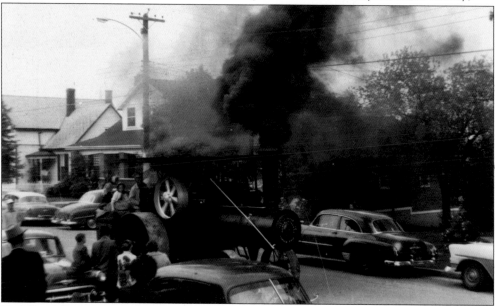

Fred (Fritz) Bauer operated the Harrison Steam Engine that was used in mushroom cellars after Prohibition. The steam locomotive usually brought up the tail of the Maifest parade because of the black smoke. Here it is traveling up Washington Street. (Courtesy of Gasconade County Historical Society.)

Rev. Robert Niehaus, who was pastor of St. Paul Evangelical Church from 1956 to 1964, is driving the tractor in this photograph of a late 1950s Maifest parade. The float was sponsored by the St. Paul Youth Fellowship. This photograph was taken on Washington Street across from the entrance to the park. (Courtesy of Gasconade County Historical Society.)

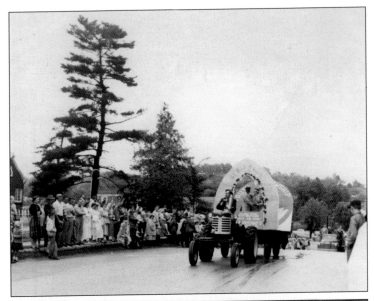

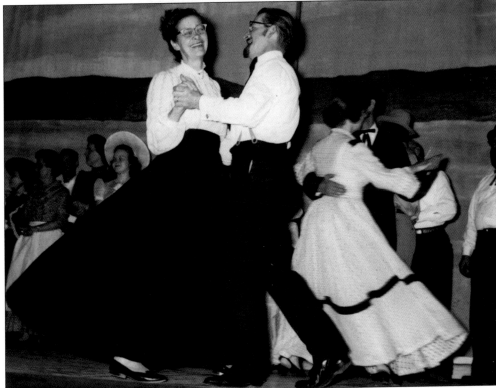

Anna Kemper Hesse and Clarence Hesse perform in a Maifest pageant during the 1950s. Historic pageants were a traditional part of Maifest each year from 1952 through 1964, and Anna, a key member of the preservation movement in Hermann, wrote the pageants. An artist and a teacher, she received an award from the National Trust for Historic Preservation in 1976. Clarence Hesse was a teacher before working in the shoe factory. He also did taxidermy, oil portraits, and worked in horticulture at the Kemper Nursery. (Courtesy of Gasconade County Historical Society.)

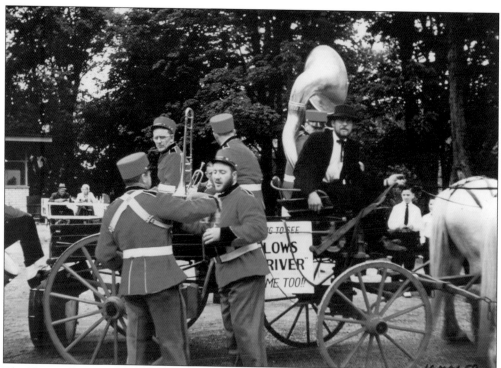

The Hungry Five, a popular Hermann band, is pictured here on May 16, 1959. Band members are, in no particular order, Billy Sanders, George Workman, B. A. Wagner, Ken Bauer, and Robert Kirchhofer. The buggy's driver, dressed in black, is Horace Hesse. (Courtesy of Gasconade County Historical Society.)

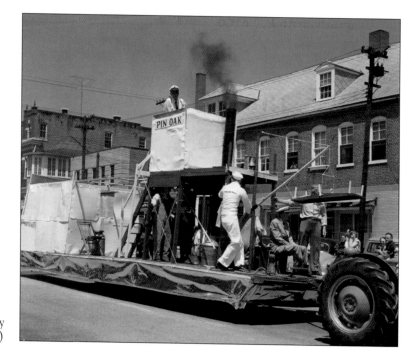

Capt. Edward Heckmann, a riverboat pilot on the Missouri River, sits in the "pilot house" of this Maifest float. Sitting in the front of the float is Capt. Bill Heckmann, also a riverboat pilot. Captain Ed drove huge steamboats up and down the river, but he never learned to drive a car. (Courtesy of Gasconade County Historical Society.)

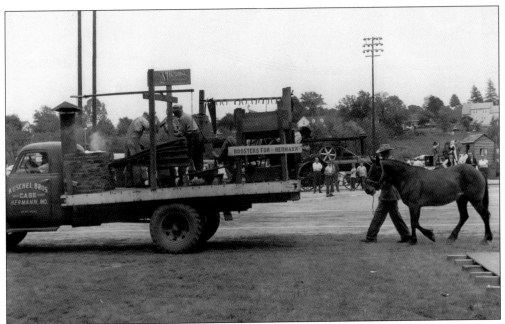

The Kuschel Brothers truck pulls a float in the Maifest parade to benefit the boosters. The float depicts an early blacksmith operation. A sign on the float advertises "Mule and Horse Shoeing—if they don't kick!" (Courtesy of Gasconade County Historical Society.)

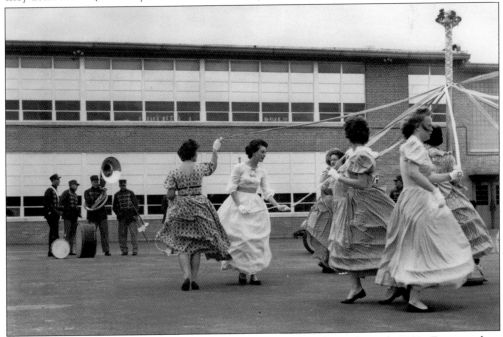

A maypole dance takes place on the elementary school parking lot in the early 1960s. Four members of the Hungry Five, a popular Hermann band, can be seen in the background. The girls whose faces show are, from left to right, Sandra Fleisch, Carol Kuschel, and Donna Graf. Hungry Five band members are, from left to right, Bill Sanders, George Workman, Bob Kirchhofer, and Vern Lloyd. (Courtesy of Gasconade County Historical Society.)

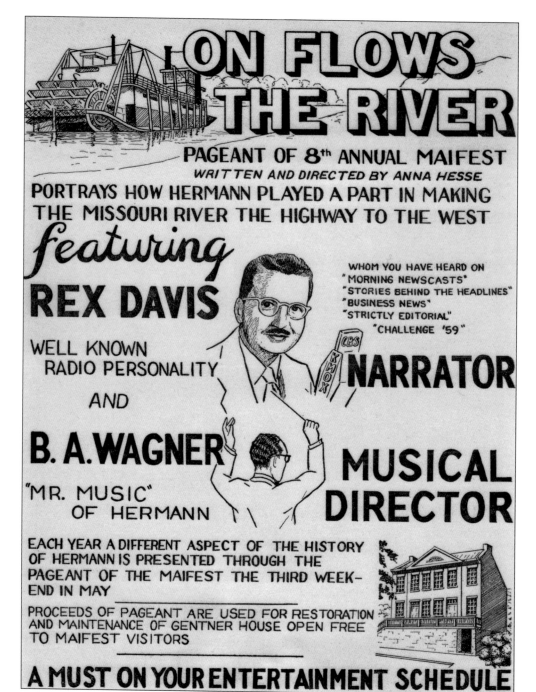

ON FLOWS THE RIVER

PAGEANT OF 8th ANNUAL MAIFEST

WRITTEN AND DIRECTED BY ANNA HESSE

PORTRAYS HOW HERMANN PLAYED A PART IN MAKING THE MISSOURI RIVER THE HIGHWAY TO THE WEST

featuring

REX DAVIS

WELL KNOWN RADIO PERSONALITY

AND

WHOM YOU HAVE HEARD ON "MORNING NEWSCASTS" "STORIES BEHIND THE HEADLINES" "BUSINESS NEWS" "STRICTLY EDITORIAL" "CHALLENGE '59"

NARRATOR

B. A. WAGNER

"MR. MUSIC" OF HERMANN

MUSICAL DIRECTOR

EACH YEAR A DIFFERENT ASPECT OF THE HISTORY OF HERMANN IS PRESENTED THROUGH THE PAGEANT OF THE MAIFEST THE THIRD WEEK-END IN MAY

PROCEEDS OF PAGEANT ARE USED FOR RESTORATION AND MAINTENANCE OF GENTNER HOUSE OPEN FREE TO MAIFEST VISITORS

A MUST ON YOUR ENTERTAINMENT SCHEDULE

A flyer from the 1959 Maifest announces the pageant "On Flows the River." Anna Kemper Hesse was the writer and producer. Rex Davis's real name was Frank Zwygart. In 1986, Rex came back for the sesquicentennial celebration and narrated the pageant "Hermann, A City," which was originally produced in 1961. (Courtesy of Historic Hermann's Museum at the German School.)

Five

LIFE ON THE MISSOURI RIVER

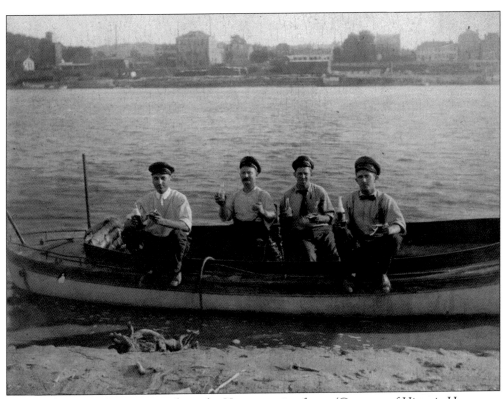

Four workers pose for a picture along the Hermann riverfront. (Courtesy of Historic Hermann, Inc.'s Museum at the German School.)

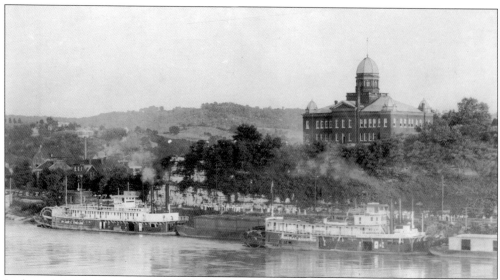

In the early 1900s, Hermann's riverfront remained a hub of the community. The Gasconade County Courthouse rises above the Missouri River in the center of this picture. During this era, steamboats plied the waters, and many were even built at the Hermann wharf. At one time, Hermann was the busiest port on the Missouri River. After the turn of the 20th century, another mode of transportation began to replace steamboats. By the 1920s, railroads had solidified their position and consigned steamboats to a bygone era. (Courtesy of Gasconade County Historical Society.)

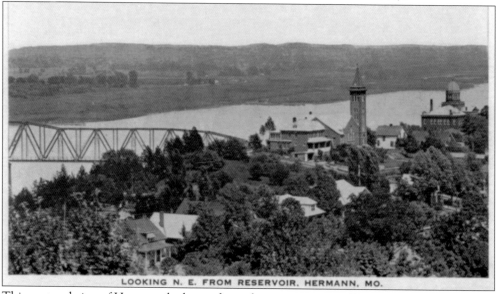

LOOKING N. E. FROM RESERVOIR. HERMANN, MO.

This postcard view of Hermann looks northeast from a reservoir on West Fourth Street. The old Hermann bridge crosses the river in the foreground. Finished in 1930, the highway bridge carried traffic between Montgomery and Gasconade Counties until 2007. Groundbreaking for the new Sen. Christopher S. Bond Bridge was held on September 23, 2005, and the bridge opened on July 23, 2007. Florence Mundwiller Kelley, who cut the ribbon for the old Hermann bridge when she was 10 years old, also got to cut the ribbon for the new bridge. St. Paul Evangelical Church and the courthouse are in the center right of this photograph. (Courtesy of Historic Hermann, Inc.'s Museum at the German School.)

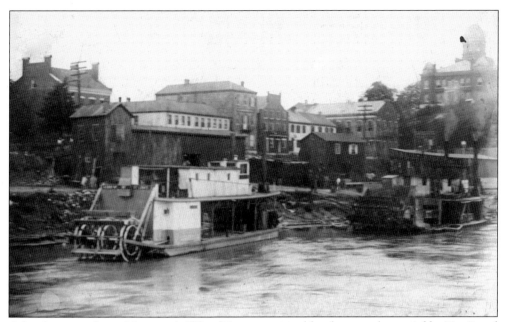

A bustling riverfront, Hermann's Wharf Street is visited by the steamboats *Ashby No. 2* and *H. E. Myrtle*. Warehouses lined the riverfront to service the riverboats and store the goods that were shipped by them. Many families had fathers, brothers, and sons working on the riverfront on the steamboats, in the warehouses, or in the shipyard building the boats. (Courtesy of Historic Herman, Inc.'s Museum at the German School.)

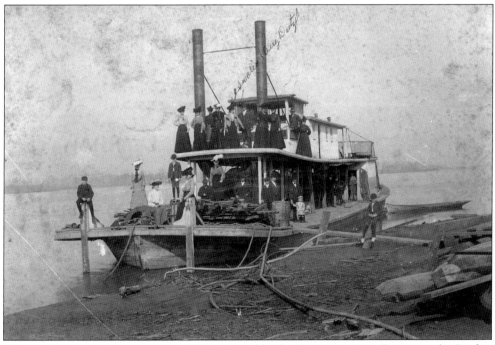

The *Peerless* visits Hermann around 1900. Owned by the Hermann Ferry Company, the *Peerless* was built in Hermann and continued to serve the area until 1903 when it was destroyed. (Courtesy of Historic Hermann, Inc.'s Museum at the German School.)

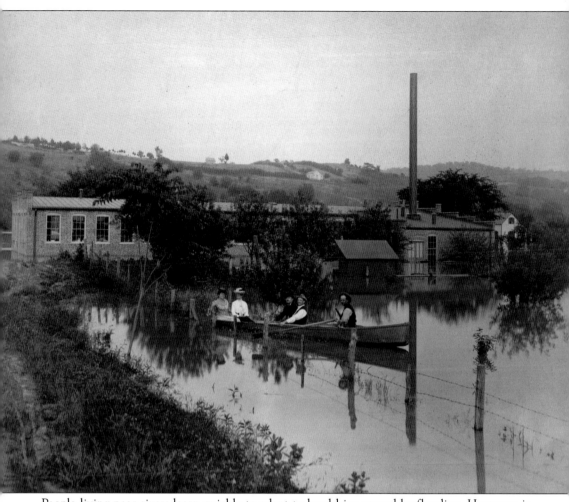

People living near rivers learn quickly to adapt to hardships caused by flooding. Hermann is no exception. In 1903, heavy floods caused severe damage in the area. The International Shoe Company factory in the background appears to be taking on water. In times like these, boats are the preferred mode of transportation. Investigating the devastation are Mrs. August Dietzel, Mrs. Robert (Katie Klinger) Walker, unidentified, Robert Walker, and August Dietzel. (Courtesy of Historic Hermann, Inc.'s Museum at the German School.)

Capt. and Mrs. William L. Heckmann Sr. are pictured in 1904. Heckmann owned and operated the Hermann Ferry and Packet Company with Henry Wohlt and his sons. All but one of William Heckmann's sons was a riverboat captain. His daughter, Dorothy Heckmann Shrader, authored a Steamboat Trilogy—*Steamboat Treasures*, *Steamboat Legacy*, and *Steamboat Kid*. (Courtesy of Historic Hermann, Inc.'s Museum at the German School.)

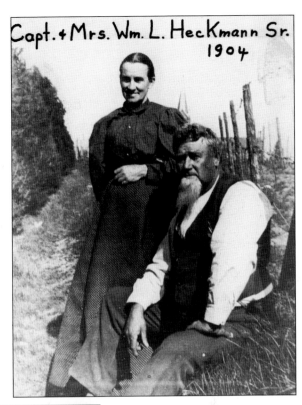

Capt. & Mrs. Wm. L. Heckmann Sr. 1904

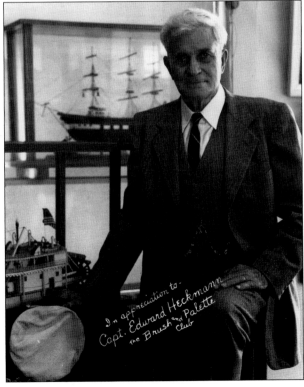

This photograph, on display at the German School Museum, is inscribed: "In appreciation: Capt. Edward Heckmann. The Brush and Palette Club." Several generations of the Heckmann family were in the riverboat business. Capt. Edward Heckmann and seven brothers were all rivermen like their father. (Courtesy of Historic Hermann, Inc.'s Museum at the German School.)

77

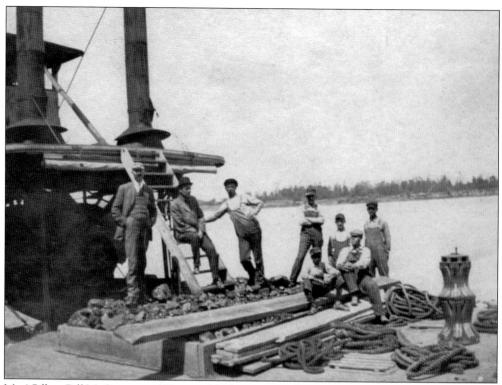

Mr. ? Silber, Bill McQueen, and Captain Heckmann are identified in this photograph. Hermann's port was the busiest on the Missouri River. Many steamboats met their fate in the area including the steamer *John Heckmann*, which sank near Kallmeyer's Bluff. Another steamer to come to its end in the Hermann area was the *Big Hatchie*. This boat exploded in 1845, killing 50 people. Thirty-five of the dead were buried in a common grave in the local cemetery. (Courtesy of Historic Hermann, Inc.'s Museum at the German School.)

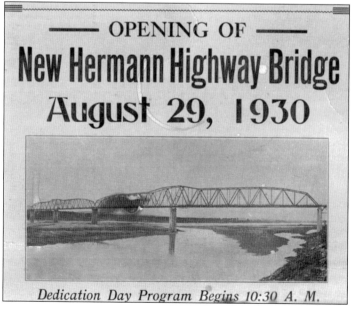

—— OPENING OF ——
New Hermann Highway Bridge
August 29, 1930

Dedication Day Program Begins 10:30 A. M.

A flyer announces the opening of the new Hermann bridge on August 29, 1930. Gov. Henry Caulfield delivered the address. Judge R. A. Breuer was the master of ceremonies. The Enterprise Military Band played in the afternoon before the speeches, and a street dance began at 7:00 p.m., with music by the Hermann Lumber Company Orchestra. (Courtesy of Historic Hermann, Inc.'s Museum at the German School.)

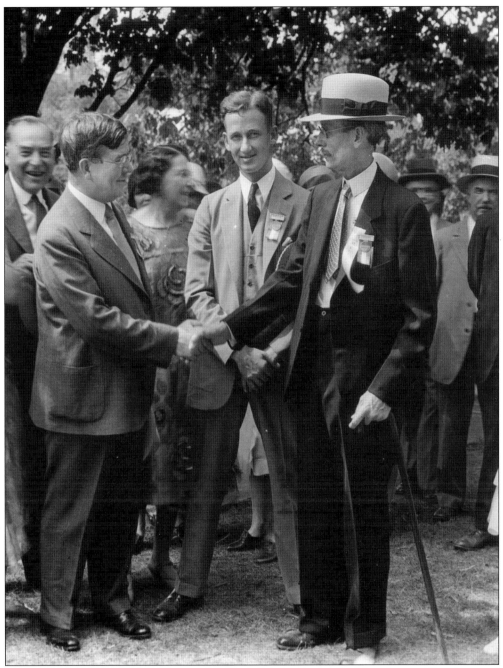

O. H. Nienhueser, Gov. Henry S. Caulfield, and the architect Leif Sverdrup, of Sverdrup and Parcel, prepare for the dedication of the Hermann Bridge on August 29, 1930. Sverdrup was the chief bridge engineer for the Missouri Highway Department. (Courtesy of Historic Hermann, Inc.'s Museum at the German School.)

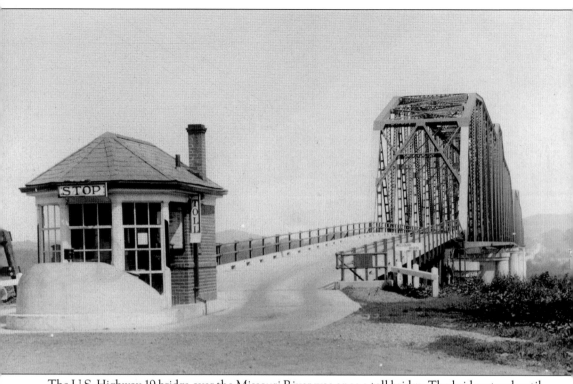

The U.S. Highway 19 bridge over the Missouri River was once a toll bridge. The bridge stood until it was replaced in 2007. A wider modern bridge, the Christopher S. Bond Bridge, was built next to the previous one. It consists of two 12-foot driving lanes, two 10-foot shoulders, and an 8-foot bicycle and pedestrian lane. The old bridge was imploded in April 2008. (Courtesy of Historic Hermann, Inc.'s Museum at the German School.)

Six

DISASTROUS TIMES

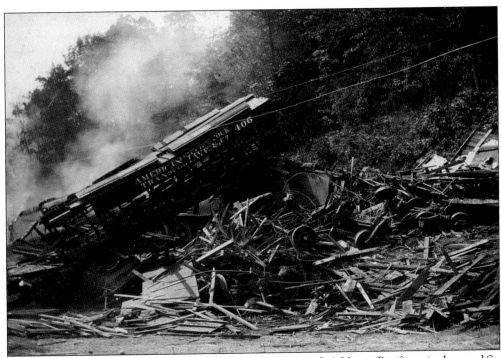

On November 1, 1855, Missouri's worst train accident occurred. A Union Pacific train departed St. Louis and headed to Jefferson City loaded with dignitaries. The opening of the track connecting the cities was a cause for much celebration. Bands played, speeches were made, and VIPs, politicians, and regular citizens climbed aboard for the ride to the state capital. The pictures in this section are believed to be of this event at Gasconade where the track crossed the Gasconade River about 5 miles upriver from Hermann. (Courtesy of Historic Hermann, Inc.'s Museum at the German School.)

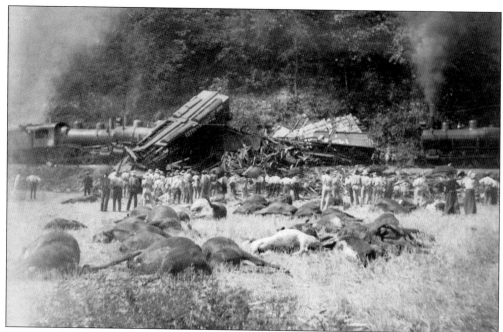

Leaving Washington, Missouri, the Union Pacific train headed for the newly constructed Gasconade River bridge. Chief Engineer Henry Chouteau originally planned for the train to stop before crossing the bridge so the passengers could marvel at the 760-foot-long span. However, when this point in the trip was reached, the train was running behind schedule, and the decision was made to push on to Jefferson City immediately. (Courtesy of Historic Hermann, Inc.'s Museum at the German School.)

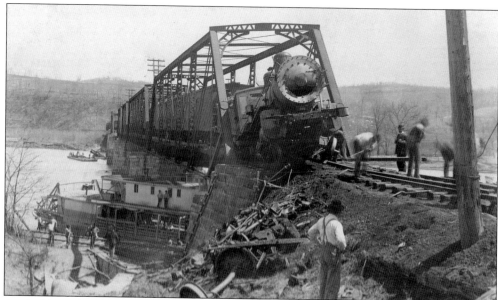

As the Union Pacific train started crossing the bridge, the temporary wooden trestle collapsed. Some of the rail cars plummeted over 30 feet into the river. The locomotive also broke through the bridge decking. Some of the cars were thrown off the tracks and rolled down an embankment. (Courtesy of Historic Hermann, Inc.'s Museum at the German School.)

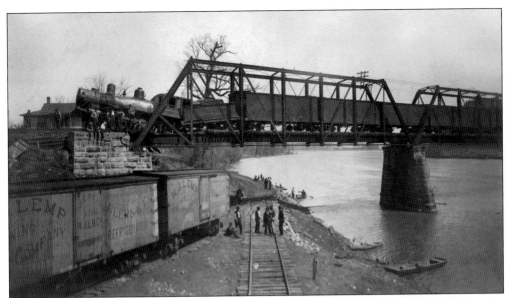

A survivor of the wreck remembered the event years later. Joseph T. Keyte was 16 years old when he boarded the doomed train headed for Jefferson City. He remembered vividly the pomp surrounding the train's departure from St. Louis, as well as the festive mood on board. After disembarking in Washington to stretch his legs, Keyte reboarded and took a seat in the first car. At the moment of the accident, he remembered hearing sounds of breaking wood and the screams of his fellow passengers. Keyte also remembered praying for protection. Joseph Keyte was thrown from his seat and buried in rubble. Unable to extricate himself, he called to a fellow passenger to come and help. (Courtesy of Historic Hermann, Inc.'s Museum at the German School.)

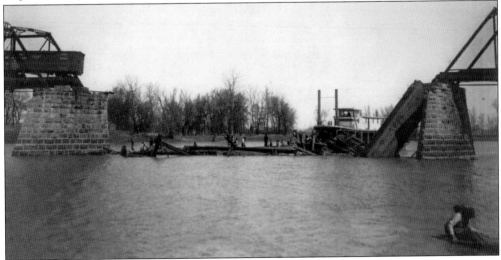

Over 30 people were killed in the wreck, and hundreds were injured. A hospital train was sent from St. Louis to assist. Many injured people were taken to Hermann, where a hotel was pressed into service as a hospital. The fatally wounded were brought to the Hermann courthouse for an inquest. St. Louis was stunned by the news. The dead included prominent citizens such as E. Church Blackburn, the president of the city council. The chief engineer of the Pacific Railroad, Henry Chouteau, was disfigured and identifiable by his invitation ticket only. (Courtesy of Historic Hermann, Inc.'s Museum at the German School.)

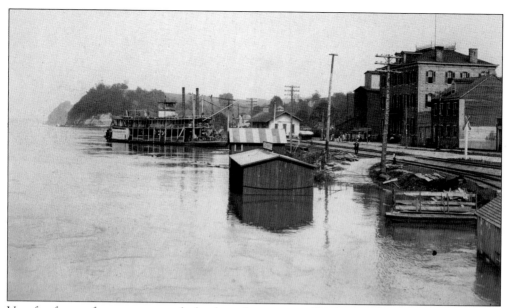

Very few forces of nature can match the sheer devastation a flood can unleash. The flood of 1903 caused much damage in the Hermann area. The Missouri River at Hermann crested at 29.5 feet, the highest stage recorded at an interval exceeding 60 years. (Courtesy of Historic Hermann, Inc.'s Museum at the German School.)

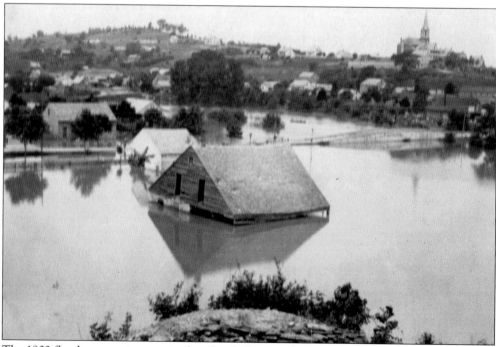

The 1903 flood was an opportunity for a local photographer to make a historical record. Edward Kemper took this photograph of the damage caused by the flood and captured Hermann as it is not seen today. The stone bridge in the photograph was later torn down and replaced. St. George Catholic Church, on a hill in the background, was renovated and expanded several years later. (Courtesy of Historic Hermann, Inc.'s Museum at the German School.)

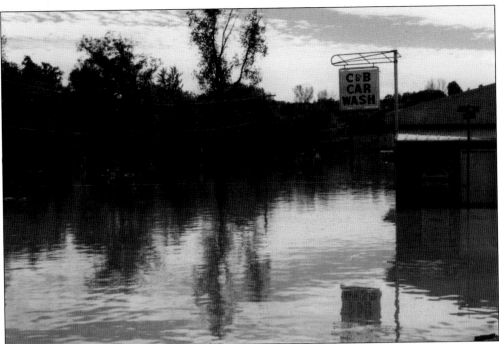

Another major flood hit Hermann in 1986. This photograph is of a flooded car wash on East Second Street in Hermann. The Pepsi machine is also partially submerged. (Courtesy of Gasconade County Historical Society.)

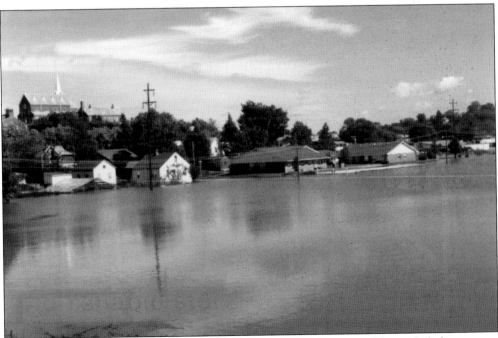

The 1986 flood also damaged residential property as seen in this image. The roof of what appears to be a shed rises above the water. St. George Catholic Church is on the hill in the background. (Courtesy of Gasconade County Historical Society.)

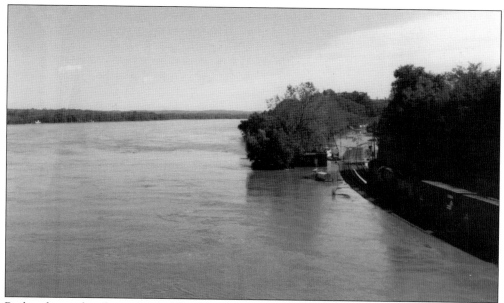

Railroads are also the victims of flooding. This picture shows waters from the 1986 event have overflowed the rail line. A train is stopped on the track. (Courtesy of Gasconade County Historical Society.)

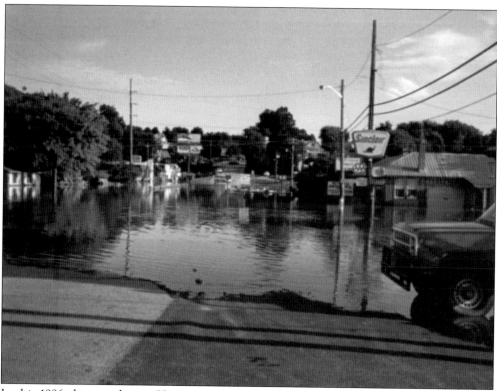

In this 1986 photograph near Hermann, a gas station appears to be flooded, as well as various other businesses. Across the street, what appears to be a residence is also getting wet. (Courtesy of Gasconade County Historical Society.)

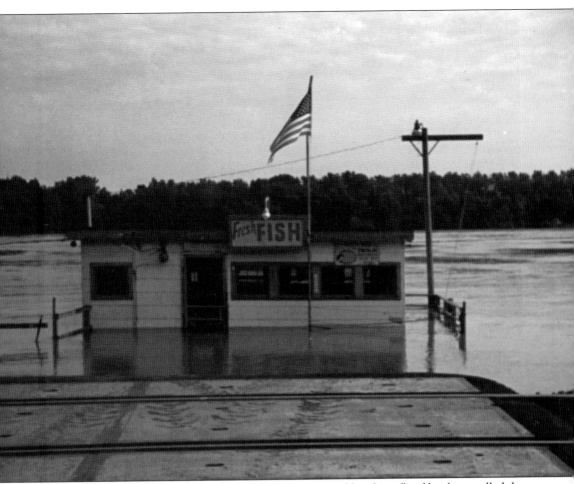

The Great Flood of 1993 surrounds this bait house. This record-breaking flood has been called the worst in modern history. Damages caused by flooding along the Missouri and Mississippi Rivers and their tributaries ran into billions of dollars. The Missouri River at Hermann was above flood stage for 77 days. (Courtesy of Gasconade County Historical Society.)

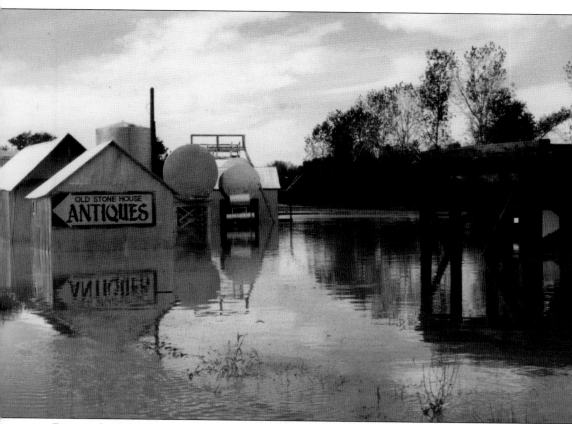

During the 1993 flood, the Missouri River at Hermann's peak height was 36.97 feet, more than 15 feet over flood stage. Businesses like this one were affected by the flood, as was area transportation, when roads, bridges, and rail lines were swamped. (Courtesy of Gasconade County Historical Society.)

Seven

LIFE IN HERMANN

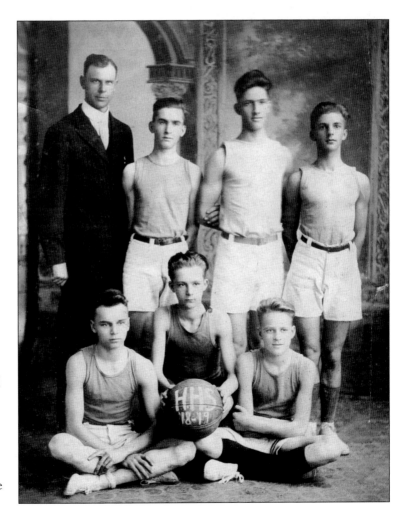

The 1918–1919 Hermann High School basketball team included, from left to right, (first row) Vernon Helmer, Everett Ward, and Rodney Heckmann; (second row) Henry Deppe, Harold Frieno, Frank Eggers, and Edwin Rippstein. (Courtesy of Historic Hermann, Inc.'s Museum at the German School.)

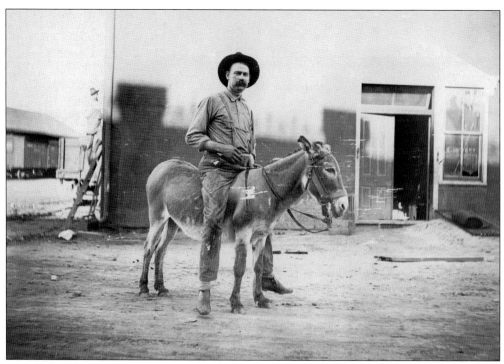

This early Hermann resident's legs were as long as his mule's. (Courtesy of Historic Hermann, Inc.'s Museum at the German School.)

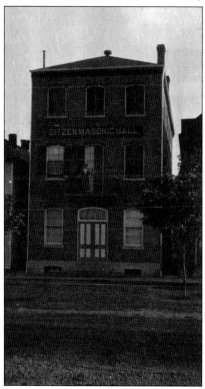

The Eitzen Masonic Hall, built in 1861, later became a residence. The building was used as a Masonic hall until 1917. It was named for Charles D. Eitzen, an early Hermann citizen. Eitzen came to Hermann from Germany in 1839 and worked in the town's only store, which he purchased in 1841. Eitzen later became involved in politics and served in the Constitutional Conventions of 1861 and 1875, as well as in the 29th General Assembly of Missouri. (Courtesy of Gasconade County Historical Society.)

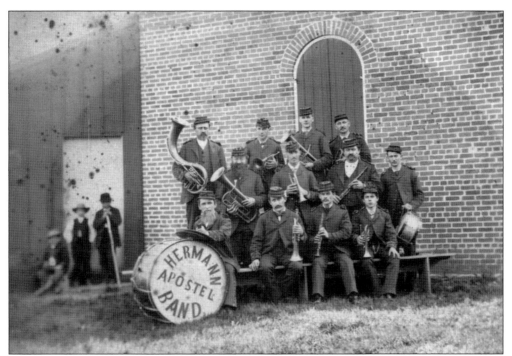

The Hermann Apostel Band formed in 1885. (The band kept the German spelling for "apostle.") Musical instruments were purchased in Germany and shipped over to the United States. The band had 12 members, one for each of the biblical apostles, and sometimes travelled to Jefferson City and Montgomery City to play. Other Hermann bands include the Enterprise Military Band, which formed in the 1920s, and the Hermann Municipal Band, which plays today and is tax funded. (Courtesy of Historic Hermann, Inc.'s Museum at the German School.)

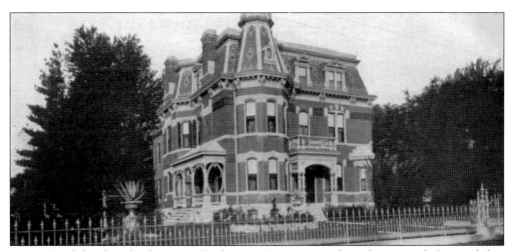

George Stark lived in this house on Washington Street across from the city park. It is said that aside from this expensive residence, Stark lived conservatively, even though he had become very wealthy with the success of Stone Hill Wine Company. Stark owned Stone Hill with his partner, William Herzog, from 1883 until 1893, at which time Stark became sole owner. Like many very old residences and other buildings, Stark's house and the wine cellars are said to be haunted by a ghost. (Courtesy of Stone Hill Winery.)

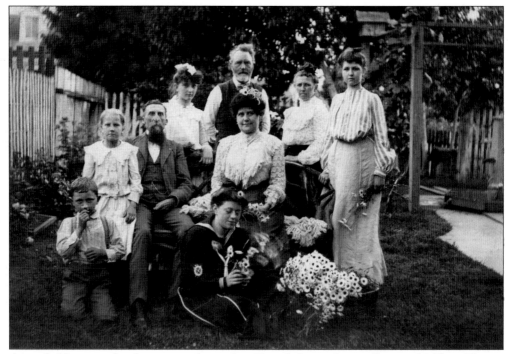

An early Hermann family poses in the garden. From left to right are (first row) Milton Klinger and Dolly Feiner; (second row) Irma Klinger and Dr. and Mrs. Freyman; (third row) Viola Klinger, grandfather Klinger, grandmother Klinger, and Gretchen Klinger. (Courtesy of Historic Hermann, Inc.'s Museum at the German School.)

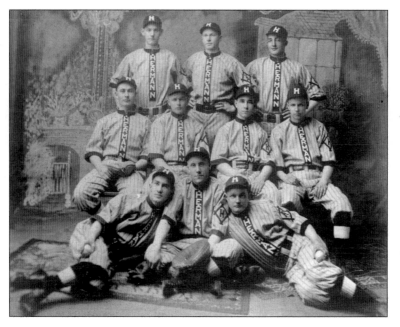

Hermann baseball team members included Julius Hermann Hansen, third from left in the second row, and Frank "Two bits" Klos, who is in the third row on the left. The other players are unidentified. "Two bits" hit a lot of doubles—which was the source of the nickname. (Courtesy of Gasconade County Historical Society.)

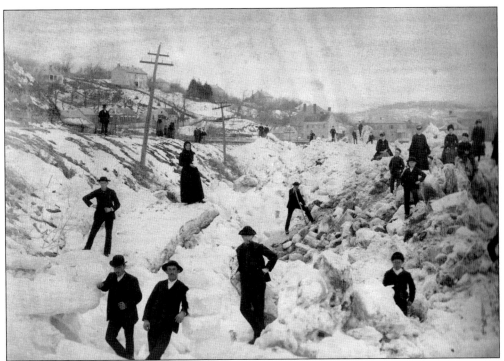

Citizens work to break up ice on the Missouri River at Hermann on February 13, 1886. R. C. Mumbrauer took the photograph. It was common practice at that time, because the river's current was not as strong and ice formed more easily, to cut ice off the river in the winter. Cutting and delivering ice became a business. The ice was packed in sawdust and straw, and much of it would still be frozen for use in the summer months. (Courtesy of Historic Hermann, Inc.'s Museum at the German School.)

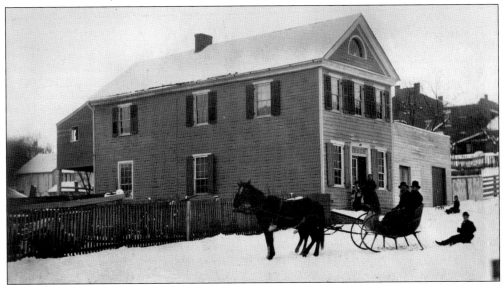

Dr. and Mrs. August Smith lived in this home, which is no longer standing, in about 1889. Hermann Bowling Lanes was built on this location in the 1900s. The bowling lanes burned and are also no longer standing. (Courtesy of Historic Hermann, Inc.'s Museum at the German School.)

The Klinger house on East Second Street was owned in 1892 by William Klinger, owner of Hermann Star Mill. Klinger owned the house from 1877 until 1905, when he sold it to the Begemann family. From 1918 to 1981, the house was owned by the Kallmeyer family, after which it changed hands several times. Most recently, it was a bed and breakfast. The building still stands. (Courtesy of Gasconade County Historical Society.)

The Graf House, built in 1892 at 504 Mozart, was purchased by Theo and Lena Graf from Dr. Julius Haffner in 1903. It was later owned by L. G. Graf and Laura D. Graf. (Courtesy of Historic Hermann, Inc.'s Museum at the German School.)

August Begemann had this building at 403 Market Street constructed for his son Louis in 1899. It is today the Wine Valley Inn. The man standing on the left is believed to be Louis Begemann. (Courtesy of Gasconade County Historical Society)

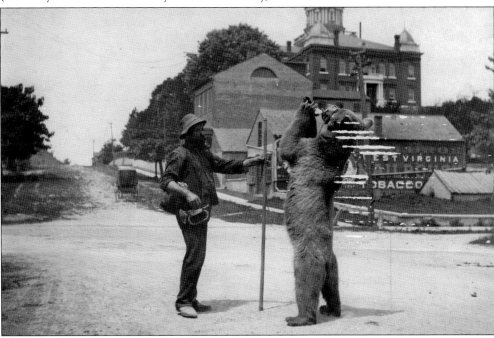

This well-published photograph of a bear enjoying some refreshment was taken between 1898 and 1905, because the courthouse is visible in the background but appears to not yet have been damaged by the fire of 1905. The traveling musician and his bear were probably just passing through town, but the photograph has become a popular addition to Hermann photograph collections of the past. (Courtesy of Historic Hermann, Inc.'s Museum at the German School.)

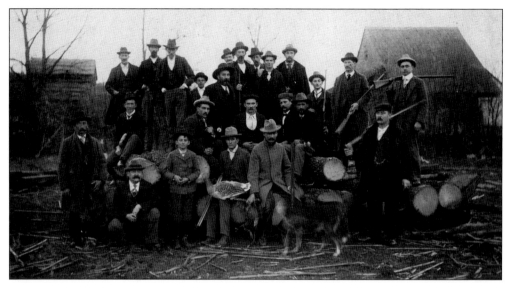

A large hunting party poses for a picture before embarking on their adventure in this photograph from the late 1800s or early 1900s. (Courtesy of Historic Hermann, Inc.'s Museum at the German School.)

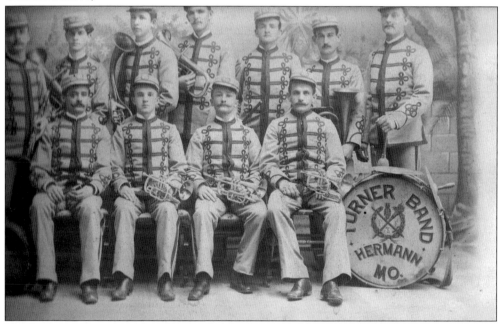

The Hermann *Turnverein*'s band was called the Turner Band. When it disbanded, the remaining members merged with the Washington group. The Turner Band gave its first program in 1869. It is pictured here in 1900. *Turnverein* was a German gymnastics movement intended to promote fitness and health through gymnastic exercise. Translated loosely as "does gymnastics" (*turnen*) and "association" (*verein*), the original *Turnverein* was an association of gymnasts founded in Berlin in 1811 by German teacher and patriot Friedrich Ludwig Jahn. Participants were encouraged to develop a spirit of *Deutschheit*, or "Germanness." Germans who settled in Hermann, Washington, and other areas brought the tradition with them to this country. (Courtesy of Historic Hermann, Inc.'s Museum at the German School.)

The Begemann sisters are featured in this photograph donated by Mrs. William Klinger to Historic Hermann, Inc. (Courtesy of Historic Hermann, Inc.'s Museum at the German School.)

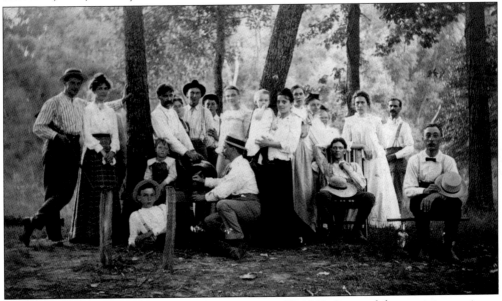

Couples picnic along the Gasconade River on June 23, 1901. Some of the participants, in no particular order, are Mr. and Mrs. Hans Glotle, Mr. and Mrs. E. F. Rippstein, Mr. and Mrs. John Helmer (Martha), Mrs. Mary Ward, and Leata Wensel Baer. (Courtesy of Historic Hermann, Inc.'s Museum at the German School.)

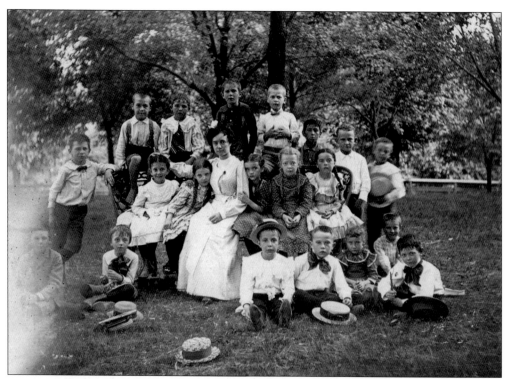

Teacher Hulda Muehl Schulmeyer accompanies her students for a Hermann School picnic in about 1900. (Courtesy of Historic Hermann, Inc.'s Museum at the German School.)

The orchestra who accompanied the showing of Huxol silent films in Hermann included, from left to right, Buddy Story, Russell Eberlin, George Story, ? Ruediger, and Louis Baumstark. The orchestra's theme song was "Poor Butterfly." (Courtesy of Historic Hermann, Inc.'s Museum at the German School.)

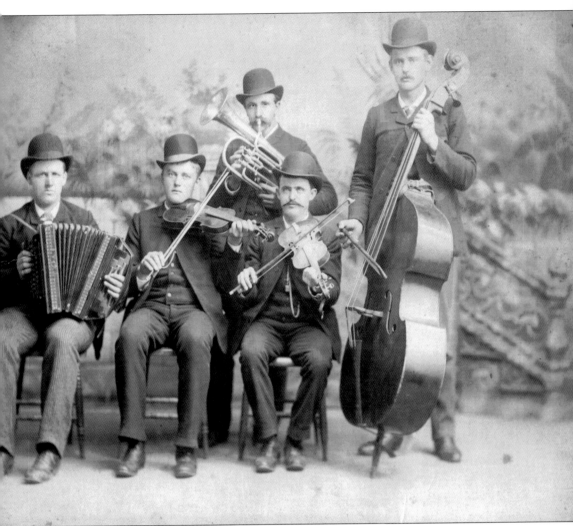

The Little Berger Orchestra in about 1900 featured, from left to right, (first row) Fritz Vollert (accordion), Conrad Ruediger (violin), Albert Baries (violin), and Edward Ruediger (bass fiddle); (second row) T. Hall (euphonium). These men sometimes walked from Berger to New Haven, carrying their instruments, to play for a dance. Berger is east of Hermann in Franklin County. (Courtesy of Historic Hermann, Inc.'s Museum at the German School.)

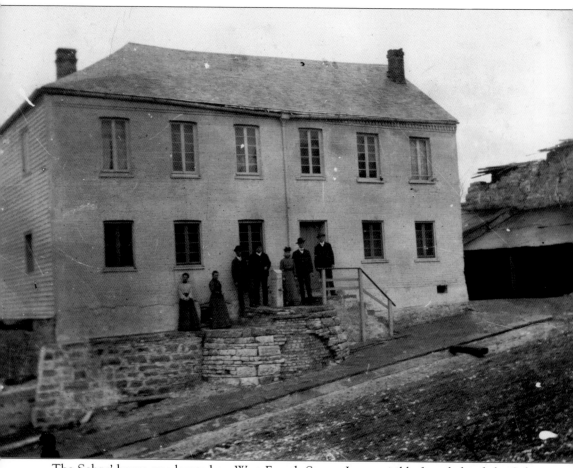

The Sohns' house was located on West Fourth Street. It was visible from behind the Sohns Winery. Henry Sohns Wine Cellars were located on Market Street, and Sohns also owned a lime-burning business in Hermann. A native of Baden, Sohns had come to the United States in 1865 and lived in other areas before settling in Hermann in 1866. He entered the wine-making business in about 1870, and in 1887, made 3,000 gallons of wine. (Courtesy of Historic Hermann, Inc.'s Museum at the German School.)

The exact location of this early Hermann residence could not be determined, but the lightning rod glass globes, like the one on the roof of this house, were a popular decoration around 1900. They served no function. Many people added the glass balls to lightning rods for roof ornamentation. Contrary to belief, the glass balls did not usually break when the rod was struck by lightning, although it did happen occasionally. (Courtesy of Historic Hermann, Inc.'s Museum at the German School.)

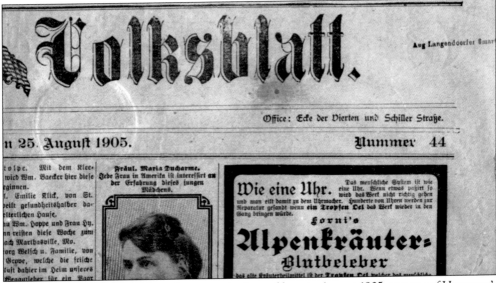

The *Hermanner Volksblatt*, whose front page is pictured here in August 1905, was one of Hermann's early newspapers. The *Volksblatt* operated from 1855 until its last issue was published on April 18, 1928. From 1875 until 1928, two newspapers were published in Hermann, one in German and one in English. The editions contained mostly the same news, but in the early years, there was more news in the German paper because German was the primary language spoken in the area. (Courtesy of Gasconade County Historical Society.)

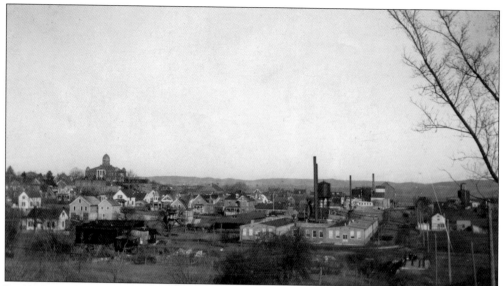

In 1903, residents of Hermann opened a shoe factory. It was taken over a year later by the Peters Shoe Company of St. Louis and incorporated into the International Shoe Company in 1911. International Shoe Company closed its plants in both Hermann, Missouri, and Paducah, Kentucky, in 1989. This early photograph of Hermann features the shoe factory on the right, with the courthouse in the background on the left. (Courtesy of Historic Hermann, Inc.'s Museum at the German School.)

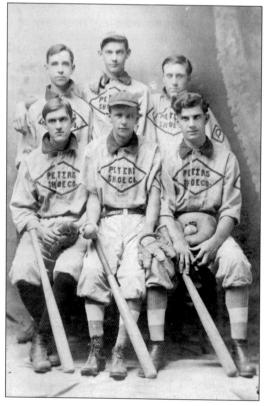

The Peters Shoe Company formed a baseball team during the early 1900s. Peters Shoe Company was in operation under that name in Hermann from about 1904 until 1911, during which time this photograph was taken. The players are unidentified. (Courtesy of Gasconade County Historical Society.)

This postcard was mailed from Hermann to Ida Moeller in another part of Missouri, and postmarked on February 19, 1915. (Courtesy of Historic Hermann, Inc.'s Museum at the German School.)

East First Street featured a concert hall in the 1930s. The temporary demise of the wine-making industry in Hermann during Prohibition dealt an economic blow to the town, but other industries, like International Shoe Company, kept Hermann alive. Today tourism is an important industry for Hermann. (Courtesy of Historic Hermann's Museum at the German School.)

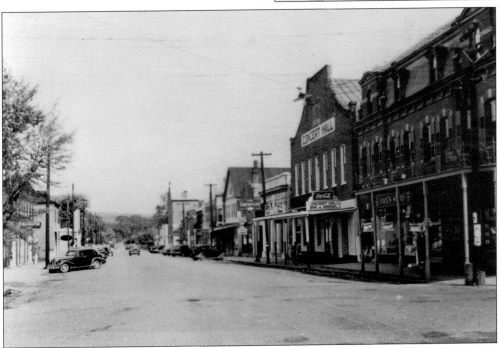

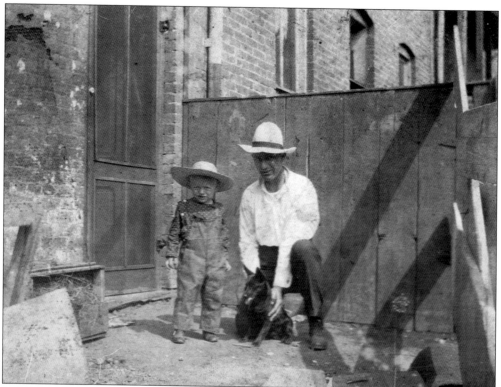

A father, his young son, and their dog provide a charming image of daily life in early Hermann. (Courtesy of Historic Hermann, Inc.'s Museum at the German School.)

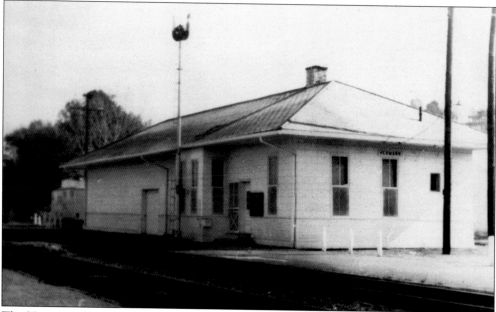

The Hermann depot no longer exists. The *Advertiser-Courier* reported on March 21, 1917, that the Hermann railroad station was being used as a hospital for sick railroad employees at that time. The building was torn down about 1976. (Courtesy of Gasconade County Historical Society.)

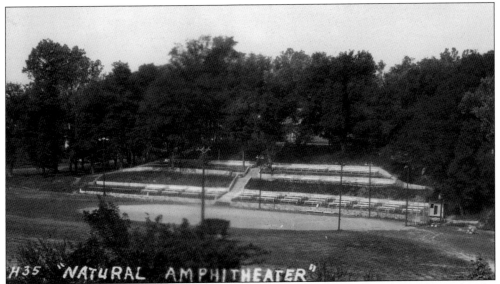

A natural amphitheater in Hermann is featured on this postcard from around 1935. Today the Clara Eitmann Messmer Amphitheatre, on Gutenberg Street between Fourth and Fifth Streets, is an open-air venue that hosts a variety of events. The amphitheatre was built in 2006, thanks to a donation by retired Hermann teacher and music lover Clara Messmer. (Courtesy of Gasconade County Historical Society.)

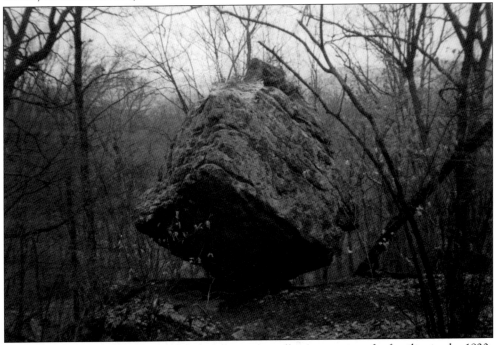

"Balanced rock" was the focus of Sunday afternoon walking excursions for families in the 1920s through the 1940s. The rock is about 2 miles west of town, off Sand Plant Road. For years, college students tried to push it over as a prank. Sand Plant Road is so named because there was a silicon sand plant near the end of the road by the river. (Courtesy of Gasconade County Historical Society.)

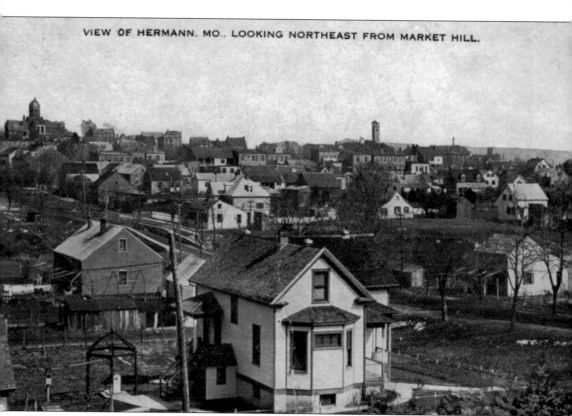

This 1917 postcard shows a view of Hermann looking northeast from Market Hill. The house in front was at Eighth and Market Streets. The location later became the site of a car wash. (Courtesy of Gasconade County Historical Society.)

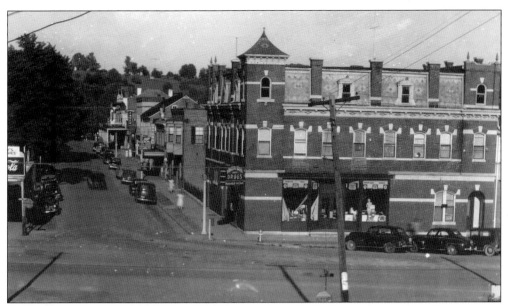

The building at the corner of Fourth and Market Streets in this photograph from the 1930s housed a drug store. The building was constructed by August Begemann for his son Louis. It is a bed and breakfast today. (Courtesy of Gasconade County Historical Society.)

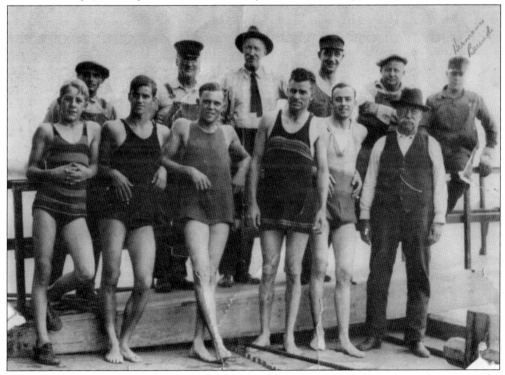

"The Hermann swim team and its sponsors" pose for a photograph in the early 1900s. The men's swimsuits are a far cry from what might be seen today. The only man identified in the photograph is in the second row on the far right: Hermann Burend. (Courtesy of Gasconade County Historical Society.)

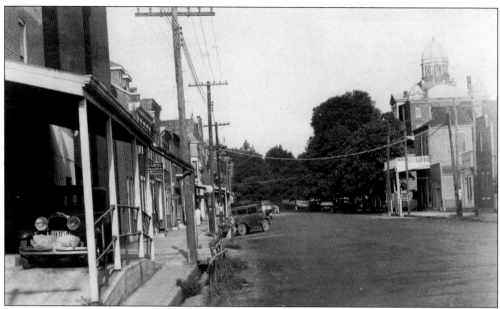

This early 1900s view of First Street looking west shows Hermann Star Mill and the U.S. Hotel on the left and the courthouse in the background on the right. (Courtesy of Gasconade County Historical Society.)

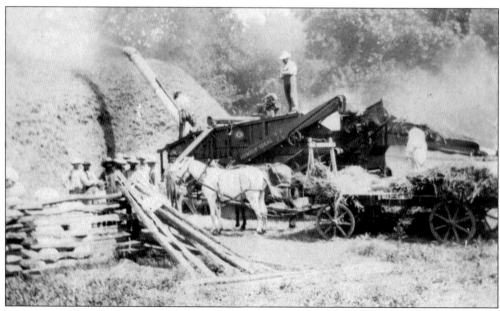

Men work with a threshing machine in this scene from about 1920. The photograph is believed to have been taken on the Henry Puchta farm southwest of Hermann. (Courtesy of Gasconade County Historical Society.)

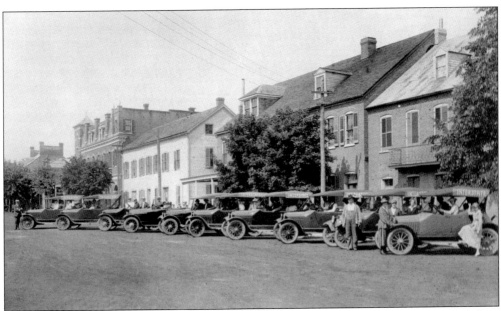

An automobile tour stops at Market Street between Fourth and Fifth Streets in this photograph from the early 1900s. The building behind the trees in the center was originally the Kimmel Hotel and Saloon and later the Nagel Saloon. The tall building with a mansard roof on the far left was built by August Begemann for his son Louis. (Courtesy of Gasconade County Historical Society.)

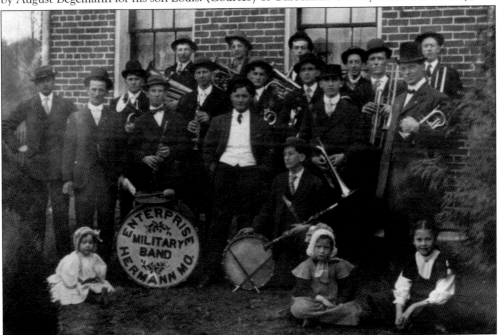

The Enterprise Military Band poses in the 1920s. This photograph was taken close to the time the band first formed, because in later years, the band members had uniforms. Hermann has a rich music heritage, beginning with the formation of *Musik-Chor Mit Blech Instrumenten* (Music Choir With Tin Instruments) in 1839. A choral society was formed in 1844, and the Apostel Band was organized in 1882. (Courtesy of Historic Hermann's Museum at the German School.)

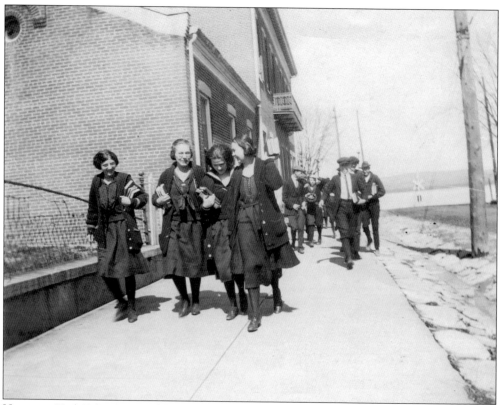

Hermann High School opened down on the riverfront in 1898. Here students are walking up from the river after school in this photograph from the early 1900s. Today the Gasconade County R-1 School District includes Hermann Elementary School, Hermann Middle School, and Hermann High School. (Courtesy of Gasconade County Historical Society.)

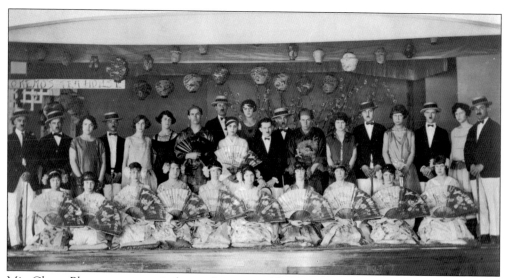

Miss Cherry Blossom was a musical comedy presented by Hermann High School students in about 1925. (Courtesy of Historic Hermann's Museum at the German School.)

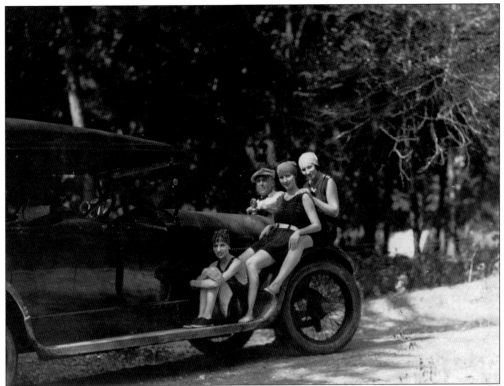

Three young women and their chaperone appear to be on their way to go swimming, according to their style of clothing, in this 1920s photograph. One of the women may be Mayme Grone, and the driver is believed to be Mr. ? Harvey. The others are unidentified. (Courtesy of Historic Hermann, Inc.'s Museum at the German School.)

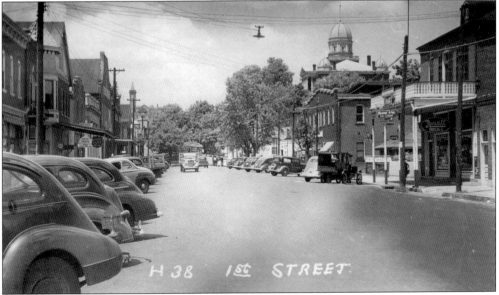

An ice truck is making a delivery on the left side of the street in this photograph looking west on First Street during the 1930s. (Courtesy of Gasconade County Historical Society.)

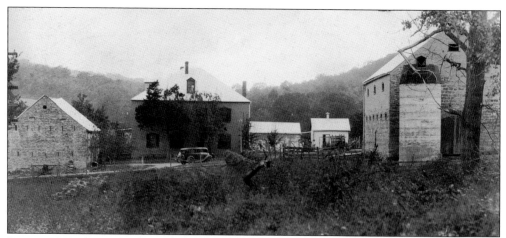

Prior to 1909, those who were disabled, poor, or unable to care for themselves were cared for by relatives or friends who received a small stipend from the county. However, many were still left without a place to live or family to care for them. In 1909, the Gasconade County commissioners chose to establish a "poor farm," where the needy could live and be clothed, fed, and cared for. Residents who were able helped with farming, cooking, and other chores. The commission purchased the Peter Danuser farm 3 miles west of Hermann on what is today Missouri Highway 100. The property consisted of a two-story stone house, a stone barn, and another stone building that housed farm machinery. There were a few smaller buildings as well. The 182-acre farm was purchased for $7,500. The farm is pictured here in the 1930s. (Courtesy of Gasconade County Historical Society.)

Mildred Triplett stands in front of Poor Farm barn in the early 1930s. She had been born on the property. Mildred later married Paul "Red" Locher. Some of Mildred's children still live in the Hermann area. (Courtesy of Gasconade County Historical Society.)

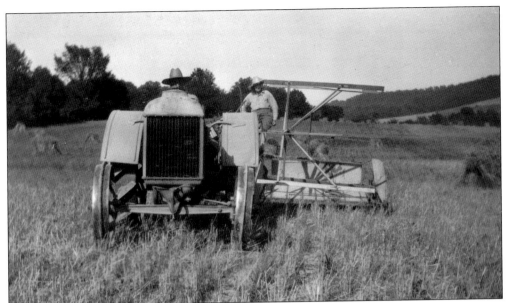

Everett Puchta sits on the Fordson tractor, and his wife Marie (Sexauer) Puchta is on the grain binder. The picture was likely taken at the Poor Farm, since the Puchtas were superintendents at the time. The superintendent of the farm received a salary of $600 per year, but the money was really intended for the entire family, since the wife worked alongside her husband, as did the children when they were old enough and able. (Courtesy of Gasconade County Historical Society)

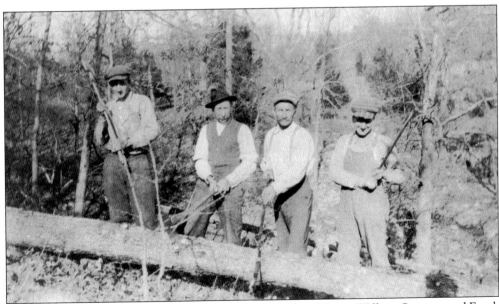

Pictured holding axes, from left to right, are Everett Puchta, ? Bopp, William Sexauer, and Frank Duffner. The photograph may have been taken on Duffner's property. (Courtesy of Gasconade County Historical Society.)

Harold and Marvin Puchta pose with their pet mule at the Poor Farm in the mid-1930s. The boys lived on the farm because their parents, Everett and Marie Puchta, operated the farm. Everett was Poor Farm superintendent. (Courtesy of Gasconade County Historical Society.)

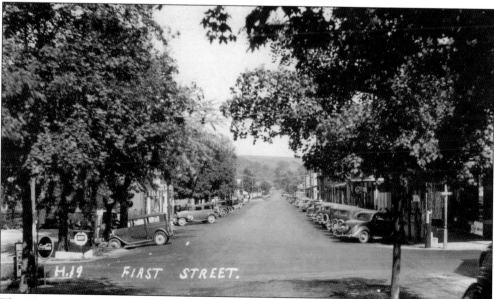

This Hermann postcard from about 1935 shows First Street looking east. (Courtesy of Stone Hill Winery.)

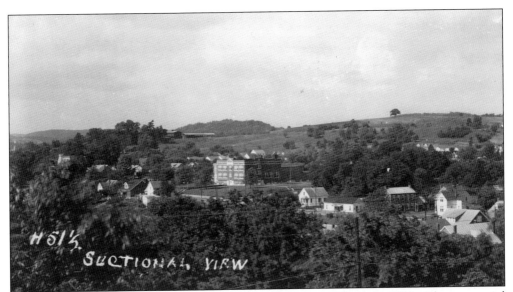

Hermann High School is the center attraction in this postcard from the 1930s. The centennial celebration took place in 1936, and this postcard may be from a series that was developed about that time in honor of the anniversary. (Courtesy of Gasconade County Historical Society.)

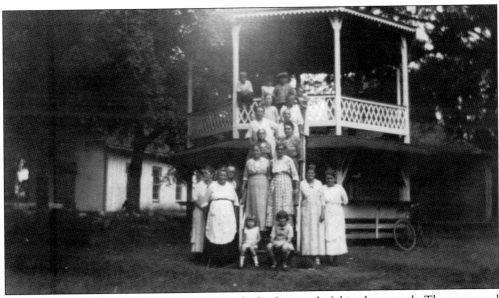

The Rotunda in the city park can be seen in the background of this photograph. The octagonal building was designed by artist Edward Robyn. The Rotunda is listed on the National Register of Historic Places. The bandstand is in the foreground. While a band played above, concessions were sold below. Mary (Hoersch) Benz is wearing a white apron. She died in 1937. The group members, possibly on a church outing, are unidentified. (Courtesy of Gasconade County Historical Society.)

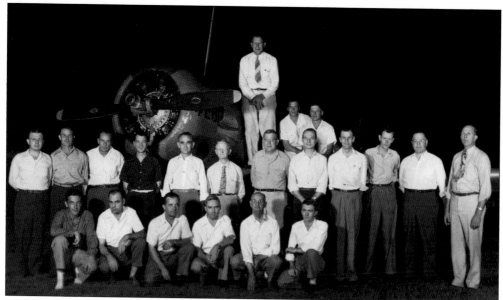

In 1947, the Chamber of Commerce brought this World War II plane to Hermann, where it was displayed on the Hermann High School lawn. The surplus U.S. Navy plane was intended to be used for vocational study. For many years, as a Halloween prank, four or five high school boys would tip the plane on its nose. The plane remained at the high school for two or three years. From left to right are (first row) unidentified, Lee Helmer, Edgar Obenhaus, O. A. Mundwiller, John Helmer, and Jack Greene; (second row) George Sohns, two unidentified, Robert Rippstein, Hugo Barner, two unidentified, Casper Bassmann, unidentified, Hugo Brueggenjohann, J. J. Rode, and Henry Rohlfing; (third row) unidentified. (Courtesy of Gasconade County Historical Society.)

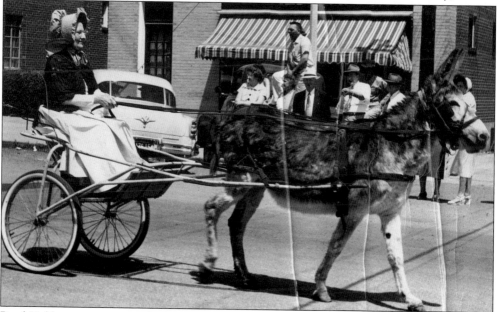

Pearl Hubberstey steers a mule-drawn carriage in an early Maifest parade. Maifest was begun as an end-of-year school picnic but has continued today as a festival for residents and visitors to Hermann. (Courtesy of Gasconade County Historical Society.)

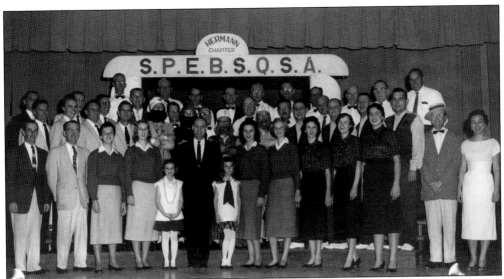

The Hermann chapter of the Society for the Preservation and Encouragement of Barbershop Quartet Singing in America conducted its annual show in the high school gym in 1955. Pictured from left to right are (first row) Elmer Simon, Burnette Wagner, LaNette Wagner, Sally Jeter, Francine Horton, Dr. J. Schmidt (director), Connie Schmidt, Margie Engelkemeyer, Glenda Paneitz, three unidentified, Earl Horton, and Mimi Schmidt; (second row) none identified; (third row) four unidentified, R. W. Rippstein, W. A. Jeter, Gilbert Schneider, Clarence Hesse, and unidentified; (fourth row) Belt Kendrick, Ben Hoffman, two unidentified, Arlie Scharnhorst, Harry Kallmeyer, two unidentified, Connie (Elmer) Ruediger, and Bill Coe. (Courtesy of Gasconade County Historical Society.)

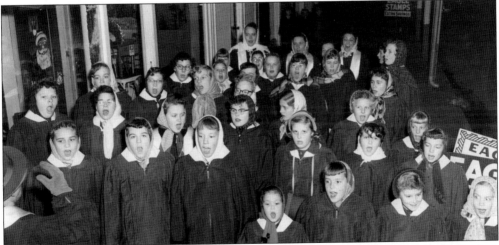

Young Christmas carolers in about 1956 included, front left to right (first row) Carol Coultor, Marilyn Kraettli, June Oelschlaeger, Diane Wagner, LaDonna Brown, Ruth Brockelmeyer, and Lois Hoerstkamp; (second row) Karen Toedtmann, Loretta Sieg, unidentified, Gisella Wegener, Juanita Saak, Pamela Reisbig, and Glee Ann Rathsam; (third row) Gladys Poeschel, Carolyn Schaumberg, Glenda Paneitz, Barbara Horstmann, Ruth Hoerstkamp, Bonnie Paneitz, and Jane Paneitz; (fourth row) Beverly Bracht, Carol Kuschel, unidentified, Darlene Haeffner, and Geraldine Swerigem; (fifth row) Ernestine Vohs, Patsy Kavanaugh, Donna Graf, Janet Lenger, and Shirley Helmich; (sixth row) Eunice Graf, Laverne Wagner, Lanette Wagner, Pat Kavanaugh, and Sandra Fleisch. (Courtesy of Gasconade County Historical Society.)

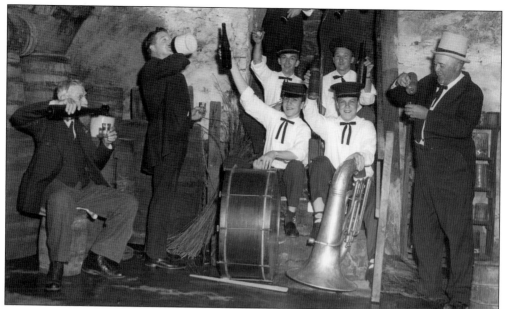

August "Sonny" Bottermueller arranged this promotional photograph for a 1950s Maifest in the basement of his house. Pictured from left to right are (first row) Otto Eberlin, Clarence Hesse, Bill Sanders, Robert Kirchhofer, and August Bottermueller; (second row) Harold Simon and Vern Lloyd; (third row) Elmer Simon and B. A. Wagner. The men in white shirts are members of the Hungry Five, a popular Hermann band that played during the annual Maifest celebrations. (Courtesy of Gasconade County Historical Society.)

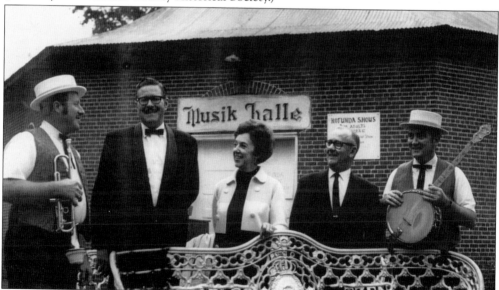

Pictured in front of the Rotunda at the city park are, from left to right, Ken Baur, Bev Taylor, Mimi Schmidt, B. A. Wagner, and Tom Warden. The photograph was taken sometime after 1964. Bev Taylor, a magician, came to Hermann in 1964 with the Stevens-Pixie toy company (later Handi-pac). B. A. Wagner was once president of Historic Hermann, Inc., and he and Ken Baur were also members of the Hungry Five musical band. Mimi Schmidt was in charge of Rotunda Shows. (Courtesy of Gasconade County Historical Society.)

Eight

HERMANN TODAY

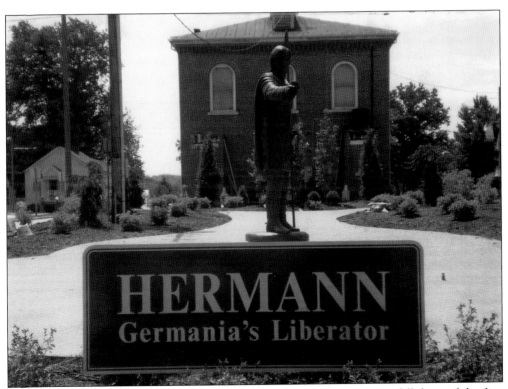

The town of Hermann is named for Hermann the Cherusker, a German folk hero of the first century, who led a successful battle against the Romans that changed the course of history. In 2009, the city of Hermann celebrated the 2,000th anniversary of Hermann's Battle of the Teutoburg Forest, and a bronze statue of the city's namesake was formally dedicated. (Authors' collection.)

Located high on a hill overlooking the Missouri River, St. Paul United Church of Christ has been a Hermann landmark for over 160 years. The first church in Hermann, it was founded on November 24, 1844, and was originally known as St. Paul's Evangelical Church. Services were conducted in German until 1910, when one English service per month was held on a Sunday evening. Services were converted entirely to English in 1947 with an exception for special events such as Maifest. Damaged by an arsonist in 1990, the church was rebuilt and is the third structure at this location. The rooster weather vane on the top of the steeple is a German tradition. In parts of the old country, a Roman Catholic church was marked with a cross atop the steeple; a Protestant church was designated by a rooster. (Authors' collection.)

The structure that once housed Sohns Winery, and the Sohns' family home still stands in 2009. Henry Sohns came to Hermann in April 1866. By 1870, Sohns was an active participant in the Hermann wine industry. His winery shipped to cities across a multi-state area. Like a good many other wineries in America, the Sohns Winery could not come back from Prohibition. For a time after the repeal of Prohibition, the wine cellars manufactured ice. (Authors' collection.)

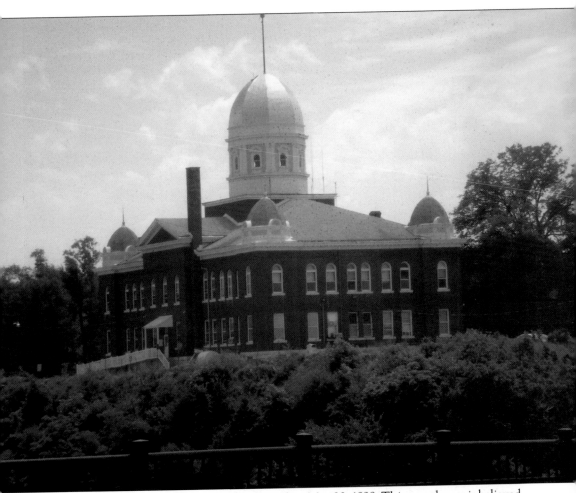

The Gasconade County Courthouse was dedicated on May 30, 1898. This courthouse is believed to be the only one in the nation that was built entirely with private donations. An early settler and leading local citizen, Charles D. Eitzen, willed the sum of $50,000 to build a new courthouse for Gasconade County in the city of Hermann. (Authors' collection.)

The Gasconade County Historical Society Archives & Records Center is located in downtown Hermann, across the street from the German School Museum. The Archives & Records Center is housed in a structure constructed in 1909 for Farmers & Merchants Bank. The Society's mission is to preserve the history of all of Gasconade County. (Authors' collection.)

In 1849, the Missouri General Assembly passed a charter incorporating a German school for the city of Hermann. The school's charter allowed the school trustees to own their building. Classes were conducted in both German and English until use of the German language in schools was outlawed at the onset of World War I. A plaque on the front of the building reads in part: "This structure was the only privately owned public school building in the state when it was deeded to Historic Hermann, Inc. in 1955 to be preserved and used for cultural and civic purposes." (Authors' collection.)

Hermannhof Winery is one of 110 early Hermann buildings listed on the National Register of Historic Places. The building was constructed as a brewery in 1848. It was later a residence for many years. The building was renovated and converted to a winery in 1974. (Authors' collection.)

Stone Hill Winery was established in 1847 and eventually became the second largest winery in the United States, shipping 1,250,000 gallons of wine each year by 1900. During Prohibition, the dark underground cellars were used to grow mushrooms. The current owners, Jim and Betty Held, bought and renovated the property in 1965. Stone Hill is Missouri's oldest winery. (Authors' collection.)

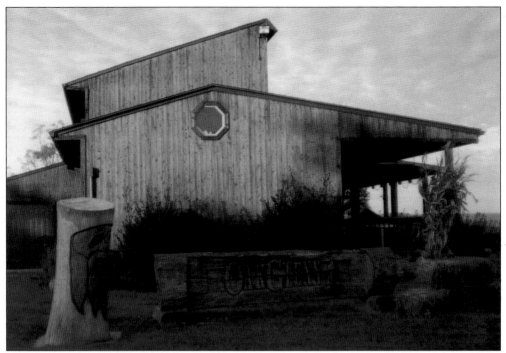

OakGlenn Winery and Vineyards is situated on land once owned by George Hussmann. Hussmann was a member of the German Settlement Society of Philadelphia, which was founded to establish a German colony in "the Far West." The land was too steep and rocky for farming, so settlers planted vineyards. Hussmann's scenic property was once known as *Schau-ins-land*, which means "look into the country." (Authors' collection.)

Adam Puchta Winery has been owned by the same family since 1855 and is the oldest family-owned winery in Missouri. Adam, along with his parents and siblings, immigrated to Hermann from Hamburg, Germany, in May 1839. The family built a log cabin on a piece of land next to the site of the current winery. (Authors' collection.)